Praise for *How to Get a Girl Pregnant*

"The universe has been known to knock you on your ass when you try to control it, but it can also offer you gifts if you're willing to pay attention," writes Chicana lesbian Karleen Pendleton Jiménez. The writer invites you to join her through the many trials a butch endures to get pregnant. In an honest, captivating memoir, Pendleton assures her readers that they are in for a surprise in the page-turning adventure. Whether you have gotten pregnant or not, whether you intend to get pregnant or not, you will appreciate the journey through to the mystery revealed in *how to get a girl pregnant*. Written with visual verve and precise prose, this memoir is an entertaining read.

—Emma Pérez, author of the novels *Gulf Dreams* (1996) and *Forgetting the Alamo, Or, Blood Memory* (2009).

how to get a
girl pregnant

how to get a
girl pregnant
by
Karleen Pendleton Jiménez

Zurita

an imprint of

Tightrope Books

Published in Canada by Zurita,
an imprint of Tightrope Books, Toronto.

Tightrope Books
17 Greyton Crescent
Toronto, Ontario
M6E 2G1 Canada
www.TightropeBooks.com

Edited by Shirarose Wilensky.
Cover design by Karen Correia Da Silva.
Cover and Author photo by Hilary Cellini Cook
Typesetting by David Bigham.

Produced with the support of the Canada Council for the Arts and the Ontario Arts Council.

 Canada Council **Conseil des Arts**
for the Arts **du Canada**

 ONTARIO ARTS COUNCIL
CONSEIL DES ARTS DE L'ONTARIO

Printed in Canada.

Library and Archives Canada Cataloguing in Publication

Jiménez, Karleen Pendleton, 1971–
 How to get a girl pregnant / Karleen Pendleton Jiménez.

ISBN 978-1-926639-40-6

 1. Jiménez, Karleen Pendleton, 1971–. 2. Self-insemination—Canada. 3. Pregnancy—Canada. 4. Lesbian mothers—Canada—Biography. 5. Authors, Canadian (English)—21st century—Biography. 6. Latin American Canadians—Biography I. Title.

PS8569.I425Z53 2011 C813'.6 C2011-902383-0

To Hilary
my lover and co-conspirator,
my companion on adventures

Contents

1. El Convento Rico
Little Italy, Toronto (March 2007)

How do I get sperm when I look like a dude and I'm older and fatter than when I picked up guys as a teenager?

It's midnight. I walk down College Street to El Convento Rico. It's a Latin bar, with drag shows on the weekends. It's only a few blocks from my home, but a whole other world. During the day the street features Italian men in bars cheering for soccer matches on oversized TVs, scholarly dykes and poets sipping lattes at cafés, upscale food markets, flower stores, and gelato vendors. At night the smell of pot and perfume fills the air, high heels crunch the last bits of ice on the sidewalks, and young men are gelled up, wearing their best club clothes.

I walk through the crowds of young couples and find my way to the large black door and silver stairs leading down. I flash my ID at the enormous bouncer and descend into an underground party. The place is packed with a diverse suburban crowd, mostly straight, but also a few downtown Latino men with undetermined sexualities. Nobody will shun you for being queer in this bar, but if you're feminine, be ready for a considerable amount of groping. I'm hoping to cash in on the atmosphere of overt sexuality.

The problem is that I have no idea how to look like someone who wants sperm. I know how to get a girl. I've mastered the lesbian cues, expectations, desires—*Damn, I want the woman in the tight black miniskirt drinking the Corona at the end of the bar.* I could watch her carefully, buy her another one just as she finishes, and then move in.

Knock it off. Focus on the men. I scan the room. Assessing men for their sperm is difficult for even the most politically astute of lesbians. What is it exactly I should look for, or avoid, in a sperm donor? In a bar, with only a few minutes to judge a potential father, I am a sucker for the superficial.

I spot a cute Latino with a puffy vest, dancing alone. It's a *Back to the Future* 1980s vest. There's a chance, I decide; he doesn't know how to dress either. I buy myself a beer, lean against a pole, and size him up. He's got a dark brown face and a dimpled smile. He's definitely handsome enough. I take two big gulps of beer and remove my blazer. I reveal a thin, black tank top. It shows off my breasts. I've got unusually large breasts. It's the only thing I have for this market. I wonder if my face is still pretty. I drink a little more, wipe off my mouth, and walk over. I ask if he'd like to dance, "*Quieres bailar?*" He nods.

We slide onto the black concrete dance floor. We bounce awkwardly a foot and a half apart. We occasionally make eye contact. I know I should try to catch his eye and smile, but I'm too shy. He isn't really looking at me anyway. His eyes dart around the room, catching no one in particular. He suddenly leans over to me and asks in Spanish where I learned the language. The music seems to get louder and I shout into his ear about my California roots, my mother's Mexican family, and my studying in Mexico City at nineteen. He explains how he's only been in the country six months. He's from Peru. His name is Jaime.

That's a good start, I think. We have a language in common. It's not so easy to find Spanish speakers in Toronto. I've got that to offer. We're both immigrants too.

I ask how he likes Toronto, and he says he does, but then mimes a cold shiver.

"Yeah." I know, it's freezing. What are we doing so far away from our families? What are we doing in this cold land? Such questions could surely be the basis of continuing the conversation, of perhaps making one warm night together.

I am interrupted by a drag queen, who parades up to the stage in a sparkling turquoise dress. I watch her as she quickly announces the beginning of the evening show. When I turn back

to Jaime, he is holding his hand out to me. I look down at it and realize that we're supposed to shake. As I place my hand in his, he pushes bulky English words out from his mouth, "Nice to meet you." He bows his head slightly, turns, and finds a place across the room to view the performance.

I rate the encounter as mildly successful, but mostly a failure. *That's okay*, I reassure myself, I don't think I could've really gone through with it. I just needed to test the waters.

I can't help but feel better when the performers sing out Ana Gabriel and Shakira. I love the fishnet stockings, the silky dresses, the long shiny wigs, the eyelashes, the tiny hips and waists, the muscular calves and arms. The flirting.

When the show ends, I head out with the crowd. I'm not ready to try again. I walk along the frozen sidewalk, avoiding the clusters of smokers and drunks. College Street at any hour is full of young, straight people trying to get laid. I'm nobody here.

2. Want

Los Angeles (1991)

It starts nearly twenty years ago. On the sidewalk leading up to my house. My mom eyes me walking in front of her out to the car. It's summer time. I'm wearing my Parks and Recreation work uniform: navy blue shorts, light blue polo shirt, sneakers. With a new haircut—compliments of a barber at Berkeley—I look like a twelve-year-old boy, a sweet-faced boy, but a boy nonetheless. I haven't yet told her that I'm a lesbian, but she can read my queerness easily in the sunlight that shines through the leaves of the maple tree.

She panics. She exclaims suddenly, "You do want to have a baby, don't you!?"

I choke on a laugh that is pure fear. I'm not brave enough to come out yet. The baby question confuses the matter. She sees masculinity, infers lesbian, concludes a loss of grandchildren. I have no idea if any of the thinking is conscious. I ignore the elephant and stick with the literal.

"Yes, I want to have a baby," I answer, "but not yet." I'm single, nineteen, halfway through a bachelor's degree, making $8 an hour at my summer job. I'm in no position to have a baby. She knows that, but she wants to put a plug in for grandchildren before I choose a life path that would limit my options.

I didn't know until that moment that I wanted a baby, but when asked the question, there was no hesitation. I knew that I wanted a baby like I knew I wanted to breathe, eat, live. I spoke it and that truth became part of how I have seen myself in the world.

I also learned in that moment that my appearance, my boyishness, would lead people to believe otherwise. As a butch, I would alarm proper women like my mother, who would see me as someone who wasn't going to make family, make babies, make home.

The last time I spoke to my mom was on my twenty-fourth birthday, five days before her sudden death. We were talking on the phone and I asked, "What should I do this year?"

"Well, when I was twenty-four I had my first baby," she paused, "not that I'm putting pressure on you."

I laughed. *Not so fast, Mom. I'm not ready yet.*

But I became ready the moment she died. It would take years to build the resources to care for a baby, but only an instant to know that I needed one. Without my mom, I was older, I was alone, I lacked family. For me, there is no stronger bond than that between mother and child. If I could no longer have a mother, then I needed to become one.

3. (Un)known
Toronto (March 2002)

I've read a lesbian fertility book. I've spoken to the local certified lesbian parenting professional. I know my choices. Here is the biggest decision: Should I go with known or unknown sperm?

There are plenty of lesbians who would never pick a known donor. Maybe it's the belief in women-centred politics, maybe it's the valuing of nurture over nature, maybe it's a question of control. What if the father attempted to take control of the child, or in general, decided to make everyone's lives miserable? That's where the fear lies.

Like, I get it, right? The longer I live, the more opportunity I've had to experience the prickliness of others first hand. In every relationship there is the potential for explosion. It doesn't matter if we're talking about lovers, friends, relatives, colleagues, students, strangers on the streets, the father of your child. There's nothing like feeling a good, solid friendship shatter into pieces over a late-night phone call. Or watching a colleague throw a tantrum in the middle of a meeting. Or hearing your lover's anger boom across the house while you feel desperate and misunderstood. There's nothing like the explosive residue of human relationships sinking into your skin to make any sensible person withdraw.

You forget all the days that were joyous; all the joking; the late nights after class eating catfish and sipping cheap wine; dancing together at the Savour women's nights; jogging ridiculously slow on cool spring mornings; gossiping on the phone to pass the time through another Greyhound bus commute. You remember vividly the pain instead, the chasm that emerges suddenly between you and this other person. The breakdown that still makes you shiver and talk circles in your head. Why take the risk to have another relationship so intimately tied to you when you don't have to? Nobody wants to be carrying the bomb when it blows up. If you

have the cash, you can simply buy the sperm online and avoid the risk.

The fear of known donors may very well be grounded in rotten experiences with power: a father who wouldn't pay child support unless he got to choose his daughter's school; a scary ex-lover who took off with the entire CD collection and the kitchen cutlery; a boss who micromanaged every ten-minute segment of one's life. But these have not been my experiences.

Both my girlfriend Hilary and I were raised by mothers. Fathers took up the space of vacations or weekends or once-a-week dinners. I've never witnessed a man in my family fighting to do more of the parenting. I'm sure it happens, but I can hardly imagine it.

Also, my childrearing experience is shaped by sharing parenting responsibilities with Hilary and her ex-husband. If anything, the joint custody situation has been ideal, with all of us getting cherished time together and helpful breaks. We have time for the kids, time for work, time to go out, and time to sleep. I'm not saying it's perfect. There are definitely moments when absolute authority would be more convenient, but overall having four parents to share the role has been lovely. I would be fortunate to find a father to contribute to the raising of a child.

I never used to put much stake in dads, because my own dad failed so miserably at it. Being raised for the most part by a single mother, I used to be the one who argued vehemently against those who said children needed fathers. I still believe that children do not need fathers to grow up to be good, confident human beings. However, I can't say I haven't hungered occasionally for a father when I've seen an impressive one deliver a speech at a family wedding, or cook a birthday dinner, or try to protect his child from danger. I admit that these are activities mothers do all the time, without acknowledgement or my gaze. And in a better world where men, as a group, were more connected to their children,

such acts would be unremarkable. But we don't live in a better world. If I could manage to bring a good father into the fold, it would be a precious gift for my child. That's the most important reason why I want a known donor.

There are other factors. I believe in biology, that the genetic material we offer a child plays a significant role in who the kid turns out to be. I don't want some creep being the father because I don't know if creepiness is inherited. They don't tell you on a sperm bank chart whether a guy is creepy; there's no category for that type of information, and I don't want to take my chances.

Finally, I like genealogy. I like history. I like the search for family lines, the shape of lives, the choices made: careers, marriages, immigration across generations. If possible, I want my baby to have the privilege to be able to trace her people.

Hilary has yet another theory. She places her faith in the knowledge garnered through familiarity. Whether the guy is a sweetheart or an asshole, the child will benefit from knowing who he is. Otherwise, the kid constructs a fantasy father: a king, a gentleman, an adventurer, a wizard, a pilot. He could be anything. The fairytale father is more grand, more chivalrous, more handsome, more protective, more successful than any real one could ever live up to. Do we really want to compete with a fantasy parent?

. . .

Oh yeah, and there's one more thing. There's Mateo.

4. The One

Chicago (April 2002)

It's three in the morning and I'm just returning from a gay bar in Chicago. I am at a Chicana/o Studies conference, where I have found the greatest selection of Latina/o queers in existence. It's a beautiful gathering. We present papers, sit through panels all day, and then party together at night. After salsa dancing, after tequila (the taste of the rough desert still on my tongue), I am riding up in the elevator with Mateo.

Mateo is a buddy of mine from my university days at Berkeley. We came out the same year, and put together socials for other queers like us who were too young (and looked it) to get into bars. I thought he was a sweet guy, and when my mom came to our graduation, I pointed him out. "What would you think if I asked him for sperm?"

My mom diligently read through his profile in the program, where it noted that he both graduated with distinction, and thanked his mother for her love and support. My mom was pleased that he was smart, and thought it was a good sign that he thanked his mother. I should also mention that he is incredibly adorable: tall, lean, dark brown eyes, beige skin, high cheekbones, impeccable taste in clothing. My mom and I decided right then and there that when I was older and ready to get pregnant, I should look him up.

· · ·

My mom had recovered quickly from my coming out a year earlier. Given my boyish persona, she said it wasn't the biggest surprise.

"How long have you known," I asked, flooded with the anxiety and relief of releasing the scariest secret in my life.

Silence.

"Since I was three and stopped wearing girl's clothes?"

Silence.

We lay together side by side in a hotel room at the Berkeley Marina. It took me until three in the morning to break the news to her, and my heart was beating out of my chest.

"I love you," she answered, raising her arm so I could crawl up against her. Lesbians were still fairly mysterious and probably a little weird to her, but I was her daughter no matter what. She knew I was happy, she knew I wanted to have children, and these were the things she cared about.

She was, however, a little distressed about how I would procure sperm. The only knowledge my mom had about sperm (obtained unconventionally) concerned her. When her best friend had decided to get pregnant as a single woman a few years before, my mom had sent away for brochures about sperm banks. She read one description after another of blond-haired, blue-eyed Aryan sperm donors, and announced that it was some type of racist, sci-fi conspiracy to colonize the world yet again. For diversity, for choice, one had to look elsewhere. Once Mateo walked up with his warm smile and gentle handshake, she and I looked to him.

What combination of characteristics do I want for my child's father? Are shared memories enough? Good looks? Ethnicity? Brains? Great clothing? A good career? Friendship? Love? Mateo possesses them all.

I want friendship; I want to love the man. Mateo and I had survived being young and queer and scared together. We had read poetry while drinking our first coffees at Café Milano on Bancroft Way. We took BART to San Francisco, hung out in the Mission District, watched feminist plays at Brava Theater, and confessed our crushes along the alley of the murals. Years later when I started publishing stories, I would send them to him. He has read, critiqued, and gushed over my work. He has loved me and he has loved my stories. We both became academics, working on opposite

sides of the continent. These days we touch base once a year at a shared conference. We embrace in hotel lobbies across the US, and spend the next four days delighted in each other's company.

I want the father to be Chicano, to have Mexican blood. I come from a mixed family, part Mexican and part white. I know how to raise a kid who is Mexican and white. The Mexican part, in particular, is very important to me.

I want a Mexican baby:

- because my mom had dark brown hair and almond-shaped eyes;
- because she fell for Latin guys, but married white like her mother told her to;
- because my *abuelita* (grandma) told me stories about the revolution and her drunk father who sang beautiful songs in a nasal voice at parties, and her grandfather who was a little man who all the women loved;
- because in the ninth grade my social studies teacher told my mom that there were too many Mexicans taking over the city;
- because I didn't admit I was Mexican when my junior high language arts teacher assumed I was white;
- because I was ashamed;
- because I'm mixed race, forever hungering to be whole;
- because I took Chicano Studies classes my first year of university and found myself;
- because the US stole California from México;
- because my mom is dead and I miss her profoundly;
- because I grew up in a Mexican neighborhood, hearing Spanish every day;
- because my mom made enchiladas for birthdays;
- because Americans think Mexicans are stupid;
- because my grandfather fought to save the homes of Mexicans in Los Angeles from corrupt corporations;
- because I moved away to Canada, where it's hard to find Mexicans;
- because I want to see my dark eyes looking back at me on a baby filled with hunger;
- and because I'm homesick.

It would also be nice if the father was gay. Mateo would know that a baby wouldn't come easily or by mistake, that it would require careful planning, commitment, tons of desire. He would know what it's like to be rendered invisible by many straight people, and a target by others. He would know what it's like to fight for love. He would know how to dance.

The other thing, and this comes from a purely paranoid part of me, is that I don't think the courts would ever switch custody of a child from a lesbian to a gay man. I've heard the story of the lesbian in Virginia who lost her child because they ruled that her deviant sexuality would be harmful. And while I don't live in the South, and there are widespread rights today for queers in Canada, you never know. Things can change. We could slip backward. I would hold onto my baby for dear life. But one thing is certain: people might not like lesbians, but they usually think gay men are the bigger perverts. A gay man couldn't take my baby away.

Finally, I should mention that a list of attributes doesn't do Mateo justice. What ultimately sold me is his elegance. It has something to do with the angles of his body, his neck stretched back, his jaw tilted slightly up and to the left, his arms folded over his thighs. He has a steadiness. He searches the room with his eyes, examining the principle characters and action. He is an observer. He is aloof like a long, silky tomcat perched at the highest corner of a room. He withholds judgment, but is ready to strike if called upon. There is something regal about Mateo. Something beautiful and natural. He sparkles, and I want those magnificent genes for my baby. I want my baby to stand out like that. He is the one. He is the father.

. . .

There's Mateo skipping down the street beside heavy steel-framed buildings in the middle of the night. I admire his striped grey slacks, pink French cuffs, the Stetson tilted over his eyes. He is a

beautiful queer thing under the streetlights. I want him to be the father of my baby, but how can I make the words come out of my mouth.

He catches me looking, and smiles back at me, unsuspecting. He lifts his chin up and down rapidly to show he's cool, then runs ahead and slides on the marble steps of the next building. We could've caught a cab home from the club, but how often do you get the chance to walk across Chicago?

I will tell him tonight. It'll be my first tangible step toward pregnancy. I'll tell him because I'm thirty. I'll tell him because he is everything I want. I'll tell him because I've got him alone tonight, after a clever escape from the rest of the conference-goers. I'll tell him because the advice I was given by an ex of mine is to give guys as much time as possible to think about it. I need to ask now.

· · ·

The mirrors around the walls of the elevator reflect my glazed eyes. I am exhausted, but my heart is pounding. What do I look like? Is my head too pink? Do I have a double chin tonight? What about my silver tie? Do I look too butch, too formal? How should one dress for such an occasion?

Does he want to have kids? How come in all these years I've never asked? Would he have a romantic/traditional image of what a mother should look like, maybe a plump, matronly woman from a commercial about making dinner for her family? I don't look like that. Or maybe he wants someone like me: queer, butch, unexpected (a postmodern partnership of sorts). Or maybe he doesn't want anyone at all and this question will make him uncomfortable for the night, or for the rest of our relationship. Long after he's told me no, the huge question will sit awkwardly between us. We won't be able to enjoy each other's company innocently ever again.

The elevator is rushing up to the twenty-first floor (mine), and then it will continue on to the twenty-sixth floor (his). My ears are

popping. I have only seconds to spare. Please let the words come out of my throat.

"Mateo?" My voice cracks.

He takes a look at me. His brown eyes grow large staring at me. "What's wrong?" He's worried. "Did you drink too much?" I look pale in the mirrors.

"No, no, it's nothing like that." The lights blink: 4, 6, 9, 12, 13, 17... *Oh no, what if he thinks I drink too much? He's not going to want to give his sperm to a woman who drinks too much. Just how many shots did I have tonight? Shit.* 19, 20, 21.

"Do you want me to walk you back to your room?" he offers, "I can get you some water."

"Mateo?"

"Yeah buddy, what's up?"

"I want to have a baby?"

He blinks.

"Would you help me have a baby?"

Now it's him who can't speak. He swallows. He raises his hand and rubs his chin nervously. He looks at the ground. He looks back at me with a big, wide face. He's helpless. The door of the elevator chimes and opens. It's my floor. I step out, but hold the door open with my arm.

"Don't say anything now." (This statement is not actually necessary as he is unable to speak at the moment. Still, it offers him a temporary reprieve.) "Just think about it." I step back and release the door. As it closes, I conclude, "I'll write to you."

August 7, 2002

Querido Mateo,

So, like I was saying in that elevator in Chicago at God knows what hour of the night, I want to have a baby. In the last couple of years I've wanted to ask you, and I finally got up the nerve. Plus, there now seems to be more of an end in sight for my PhD. I just passed my comprehensive exams two weeks ago. I'm hoping it will take me no more than two years to do the dissertation. Hoping.

I've wanted to ask you because on the most basic level, in my gut, I think you are a good man. I like the man full of feeling, the one I spoke to two years ago or so when Amado had just become your boyfriend, when we got to spend time talking about relationships, love, passion, messy stuff, etc. I like your careful thinking about the lives of Latinos when I hear your papers. I like your humour at dinners in random conference cities across the continent. I even admire your capacity to say no to too many meetings, to go shopping when conference days are too long. I figure the fact that you're Chicano, smart, handsome, gay, and well dressed are all bonuses.

Also, I appreciated the way you cared for me when my mom died, all the phone calls, the little gifts you'd package up and send to me arriving on my doorstep, cheering me up in the depressing months that followed. This might sound funny, but it also means a lot to me that you like my writing. Of course, stories are different than people, but I write about my adventures, and all the crap that I survived when I was a kid. That's the core of who I am. And you're the strongest believer in it.

Now what? Suddenly writing seems so difficult. Hmmm. Well, let me try to explore the full range of what I imagine having a child with you might look like. You pick the option that would work best for you, and of course I realize things could change over the course of a childhood.

Best case scenario, we end up getting professor jobs in the same city. We get to share time with the baby/kid. The kid gets to grow up having me, you, Amado, and Hilary loving/looking after him/her. I realize this will probably never happen, but I want you to know I am open to this. This is currently the arrangement we have with the father of Hilary's children.

1. We live a nine-hour drive apart. The kid spends most of the time with me, but gets to see you at various times throughout the year—holidays, summertime, whenever, as often as we can get the two of you together.

2. We live on opposite coasts. We manage to see each other twice a year and spend that time together.

3. Or even if you wanted to help me with this, but didn't want to be part of the child's life, I would understand that too. But I would at some point want to be able to tell my child who his/her father is. Just because I think that's important.

4. On that note, what you would want to be known as could also be worked out . . . Dad, Uncle, the friend who helped me, whatever you want.

5. Finances are also a question. Ultimately, I can take full financial responsibility for the child. However, if you want to help with money and responsibility, that would be fine too.

In terms of my timeline, I've always told myself I would have a baby before I was thirty, only I'm thirty now and it's not going to happen this year. Plan B: I finish my dissertation, get a job, get better immigration status (not necessarily in that order), and give you a call. Or I accomplish two out of three, or maybe even one out of three—in no more than three years regardless. Part of me wants to wait until I have all three of these things and therefore feel more

confident about my financial status; part of me just really wants to have a baby ASAP. Waiting for a job would be easier though, because maternity benefits are really great here, and there is also partially subsidized daycare. I am in the process of applying for landed immigrant status as Hilary's partner. In terms of Hilary's finances, she really needs to spend the money she makes on her own kids, but she also houses me in a nice place and if I went through hard times, she would definitely take care of me and my future child.

More in general about Hilary: she looks forward to us having a baby. We've saved clothes, high chairs, and a crib in the basement. In her children's life (Joshua, 7; Maya, 5), I am known as the "extra mom." I am basically more than an aunt and less than a biological parent. The kids are clear on who their mom and dad are, and how I am an extra person to care for them. They literally just asked me one day to be their extra mom and I said yes. I anticipate that Hilary will play a similar role for our child.

As for our kids now, they are always asking me when I will have a baby and seem to be pretty enthusiastic about the whole idea.

As for my family (the short version): in California I have two brothers who are pretty close; a very cool sister-in-law; two young nephews and a newborn baby niece; a father who is not close; a grandma who is at the end of her life; and some distant first cousins. Spread across the US I have some caring second cousins, and in San José I have my close friends Julia and Kathy. Also, Hilary's brother, sister-in-law, and mother live nearby and could help out.

My mom was a very devoted, loving mother and, fundamentally, I bring what she taught me to parenting. Being an extra mom for Hilary's two kids makes me understand in the flesh what kind of work is involved. I feel I can do a decent job of things.

So, that's all I can think of right now. I imagine you might have many more questions. I imagine you'll need to talk through all of these ideas with Amado. Take your time. I really hope we'll be able to have a child together, but if it doesn't work out, if nothing else, I'm glad I've had the opportunity to tell you how highly I think of you.

Take care . . . *con mucho cariño*, Karleen

Miami (April 2005)

What makes a Chicana/o Studies conference different from any other academic conference I've been to is the *Baile*. On the last night of the conference the ballroom fills with cumbia, salsa, and merengue. Professors and students lose their blazers and button-down Oxford academic wear in favour of silk guayaberas, leather miniskirts, and ball gowns. University titles, hierarchies, and status fall away to dancing and beer. Queers dance in a big group surrounded by straight people, and nobody picks a fight. Anyone can ask anyone else to dance. It's the last chance to find the smart, hot femme who gave the paper on transnational sexualities and hold her close for a three-minute song. It's the last chance for all conference hook-ups, and there is both joy and desperation to the night.

Tonight we're in Miami, and a Cuban band takes the stage. We try to keep up with the fast beat. My hips are tense; I need to loosen up. It always takes three or four songs and a shot of tequila. I close my eyes and listen for the beat to move me.

I've missed the last two years of the Chicana/o Studies conference due to money (it's hard to be a grad student), and papers (I was restricted to Canada until I could get my landed immigrant status). I've missed two years of Mateo. We haven't spoken about the baby since the night in the elevator. He hasn't responded to my letter. It's not as though I've waited beside my

phone for him. I've been giving us both time. He's needed it to decide if he could commit to a baby. I've needed it to finish school so that I could afford to have one. I've focused completely on my dissertation, comforted by the fact that I have started the process of getting pregnant, and that I will resume as soon as I have the chance. I've worked day and night like a crazy woman to finish; I've had the dream of a baby to drive me. Also, if I don't call him, I don't risk hearing the wrong answer. I'm not ready for that.

I don't know what to expect. Maybe he hasn't spoken to me because the answer is no, and he is afraid to tell me. Maybe he doesn't know what to say to me. Maybe he is afraid of losing me. I wouldn't stop being friends with him over his sperm, but he doesn't know that. We've avoided the topic over the last three conference days, hearing one verbose paper after another, pretending the question is not hanging on top of us. But I'm not leaving the *Baile* without an answer.

I spot him an hour and a half into the dance, at the perimeter of the floor. He is drinking a mojito with mint leaves and ice stacked to the top. He's got his hand pushed into the pocket of his black slacks beneath a baby blue dress shirt that glimmers when the disco lights angle onto him.

To get airtime with Mateo these days is not so easy. It's not like when we were in school together. When we're in a crowd, he can't be the carefree guy I know. He has become an important man. He holds authority at his university and respect amongst his colleagues. He is also looked up to (or envied) by the other gay men at the conference. He is successful, handsome, and out. When he enters a room he locates a comfortable spot and awaits the lineup of fans coming by to say hi. I check out the men nearby him and chart their courses over to Mateo. I need to slip in between Enrique sitting three tables to the right, and Julio dancing ten paces in front of him. It requires coordination, like scooting through a highway full of traffic. I decide to make my move.

I motion to the group I'm dancing with that I need a break and head over. Mateo smiles at me when I approach. *That's a good sign,* I think. I stand beside him and we watch the dancing together. A big circle has formed and couples take turns showing off. The best, as always, are Adriana and Sandra, shoulders, hips, thighs, toes, all perfectly in sync as they spin once more. I could watch them forever.

"They're gorgeous, aren't they?" I declare.

"They move so smooth together, like water, like a river," he adds.

I can't wait a minute longer. I can't wait until they finish their dance. I can't wait until we're drunk at three in the morning. I can't wait for small talk. "Mateo?"

"Yes," he answers.

"About that letter?" I ask with my voice shaking. My eyes focus on the purple square patterns on the carpet. *Look up, Karleen. Look him right in the eyes. Keep breathing. You're asking him for life. There is nothing shameful in this.*

"Yes," he says again. "The answer is yes."

A smile rises right up from the corners of my mouth and warms my whole face. I jump up and hug him. "Oh God, Mateo, thank you, I'm so happy."

He laughs into me. "You're welcome."

"I think we're gonna make a cute, smart kid."

"Of course," he answers seriously.

"I'll call you. It'll be this summer. I can fly out to find you when the time is right."

He kisses me on the cheek. "I'll be ready. "

Toronto (June 2005)

My period is regular. I've counted for the last three months and it has arrived every twenty-nine days. I am a textbook example of a cycle. As a lesbian, I've never had to count before, and I am rather amazed that anything about my body matches what is considered "normal." My ex tells me to start trying on day nine of a cycle. The cycle begins with the first day of a period. "Inseminate on day nine," she explains, "then day eleven, and day thirteen." This is how she got her lover pregnant.

It is early summer but already hot in Toronto. The air is heavy and wet. The ground is swelling with life, roses and daylilies blooming across the city. I graduated last week with my PhD in the giant steaming tents on the lawns of York University. On the day of my graduation, I received a call offering me a full-time contract position. I have paid employment. I am free of my studies. For the first time in my life, there is nothing holding me back from getting pregnant. I am ecstatic, and terrified. I've got no more excuses. I either call Mateo now, or I'm full of shit and don't have the guts to do it.

I've been waiting so long for this that my excitement quickly trumps my fear. I pick up the phone and call Mateo. He's not home, so I leave a long, awkward message. It goes something like this: I am ready for him. I'll buy my ticket ASAP. I'll need to fly out next week to reach him at the right time. I'll need his help Friday, Sunday, and Tuesday. I can get a hotel nearby; I don't want to inconvenience him and his partner Amado. He should call back to confirm that he'll be in town next week.

I wait for his call until it gets so late that I fall into sleep.

· · ·

I jog along the streets of my neighbourhood when I wake up the next morning. I feel calm. School is out. Winter has disappeared. Canadians fill the streets with glee, soaking up the sun. The front

yards are boxed off into tiny gardens with bright colours. The magnolia trees hang over the sidewalks, dropping white flowers along the path. I dream about our baby. He is a boy with dark hair and eyes. I can see his chubby cheeks underneath a blue sun hat that shades his face. He is sitting up all by himself on a picnic blanket in the park. He looks up at me, smiling when I take his photo.

I warn myself to stop. *Don't dream like that*. Who knows if I'll get pregnant? What if I have fertility issues that I don't know about? What if it takes too many tries and Mateo decides to stop helping me? What if I can't afford to keep flying out to California to meet up with him?

Last month I called a clinic to see if Mateo could store sperm at a bank here for me to use. I figured it would be easier (less travel) and less expensive. After they informed me of the six-month hold required for testing, they warned me that it was against the law to store and inseminate "homosexual" sperm. I quickly lied and assured the nurse that he was an upstanding heterosexual man. She informed me that his sexuality would be determined during a one-hour admission interview with their staff. I hung up and looked at the price of airplane tickets instead. I was outraged, but stuck. Mateo wouldn't pass for straight after five minutes, if that. I also didn't want to ask him to lie to the doctors.

. . .

The little baby of my dreams lifts his arms toward me. He shouts a loud baby cheer. He wants me to pick him up. I tell him to wait for me. Wait just a little longer.

. . .

Mateo calls shortly after I return from my jog. His voice is soft and strange. Something is wrong. I am confident and reasonable and ready to solve whatever problem he seems to have. He has already told me yes, so any other dilemma would be trivial.

"What is it, Mateo?" I demand, "Why do you sound so far away?"

He is talking about his boyfriend. Amado heard my message. Amado is upset. Over the last three years, Mateo neglected to mention the plan for the baby to Amado. He probably should have. He is sorry. He feels bad. He can't do this to Amado. He won't do this to Amado. He is sorry. He wanted to help me. He is sorry. There is nothing to be done.

This isn't possible. I will straighten this out. I am rational. I can fix it. Mateo already said yes. The baby boy in my dream has already reached for me, smiled at me. I will talk to Amado and convince him. Amado is furious. Not with me. None of this is about me. Amado hopes I understand. He's a good guy. But not today. Today he's a hurt boyfriend who wasn't told. Today he is furious. He hopes I understand. He's sorry.

I am lying facedown on the living room couch when I hang up the phone. I cry into the leather and the tears ball up against my face. I make quiet, deep sounds of mourning. Hilary finds me and covers me with her body as I shake.

"Oh, baby," she whispers into my hair, "Oh, sweet baby girl."

5. The Others

It takes me six months to recover from Mateo. It takes time to build back up the strength of heart and the confidence to ask another man. It also takes time to locate and pursue one.

Before Mateo turned me down, Hilary and I decided to tell Joshua and Maya about my desire to get pregnant. We didn't want to spring it on them all at once. We didn't tell them about the specifics (not the man or the month), but the long-term goal. While they both appeared excited by the prospect of a little brother or sister, Joshua was concerned with logistics. At seven, he is already aware that a man's help is needed somewhere in this process.

"But you don't know any men," he informed me.

"Sure I do," I answered defensively.

After all, I never even made friends with other girls until high school. All of my best friends growing up were boys. Surely I must still know some men. Mateo is my friend, regardless of whether or not he can give me sperm. It's just that Joshua has never met him. But there must be others. I mean, if nothing else, I work with a lot of men. I just can't think of anyone in particular at the moment that I want to ask. *Shit.* Maybe the kid has a point.

Joshua's not one to leave you alone in a jam. While I'm still moping over Mateo, he moves things forward. On an early Saturday afternoon, we take the kids to see a movie at the Carlton. The four of us wait patiently at our streetcar stop on College, watching the world walk by us.

Joshua has always had a loud voice. He's got nothing between a whisper and a bullhorn announcement. I don't know why; everyone else in the family is soft spoken. That's just the way he came out. All of a sudden the nine people standing on the corner at that moment can hear him.

"Karleen is my extra mom," his seven-year-old voice states proudly.

A tall, plump man in sunglasses lowers his newspaper and politely acknowledges Joshua's attempt at small talk.

"She's right over there," he points to me. I wave back shyly. A few others in the crowd grin and carry on like they're not listening in.

"She's planning on having a baby."

A nervous laugh leaps out of my mouth. I nod, *yep*, at the man, *it's true*. I avert my eyes from the rest of the crowd.

"You know," Joshua continues in his most serious voice, "she's gonna need a man to help her."

"Whoa," I exclaim, "Joshua, look the streetcar is coming." I nudge him away from the man as the crowd on the corner erupts in laughter.

I clearly need to step up my efforts at finding a man if my seven-year-old feels compelled to pick up guys on the street for me. I try to think of the men I know, only to discover that I don't know any well enough to ask this highly personal question. It's partly the fault of moving around so much. I've lived in three different cities since I left home at seventeen. I've got so little history with anyone. Nobody in Toronto knew me with long hair in high school, or when I drove a '64 Rambler, or when I came out, or published a magazine, or had dyke drama with exes. Nobody ever met my mom.

I am asking a guy to trust me with a whole life, a life that is blood. But nobody here has known me long enough to discern whether or not I'm totally stable. That kind of knowledge only comes after watching someone for a decade or two or, better yet, having access to multiple generations, knowing an entire family's standing within a community.

Of course, straight people hook up all the time without a detailed background check. They can have babies with strangers accidentally. In this scenario they are only asking for sex, and sex can be so good that a baby is an afterthought. A baby is not

the reason for the encounter; a baby is the fear, the worry, the potential obstacle to pleasure. Or a couple could argue for years over whether or not to have one, only to find that the birth control didn't take one month and a baby will be coming whether they like it or not. Heterosexuals may or may not have to ask the question or make the decision; sometimes the sex just does it for them.

But I'm not asking for sex. To ask for a baby is much more complicated. What should a potential father know about me before I ask him for sperm? How much information is required? What should I know about him? Perhaps a full medical history would be useful knowledge, a life narrative would be nice as well, and it couldn't hurt to have financial statements.

I strategize. If I don't know any men well enough, then I need to reach out to acquaintances, and move them up to the next level. Get to know them. Become better friends.

. . .

Tomás is a big, round man. He has thick curls covering his head, dark blue eyes, and freckled skin. He has a soft belly that hits me when we hug. I love the way his body envelops me in those brief moments. It reminds me of my mom, and I feel safe.

Tomás is a poet, artist, and in general a free spirit, who is only serious about music. He loves to dance: salsa, merengue, anything Cuban. He's a Colombian (not Mexican, but still Latino) who moved to Georgia, but lives today in Buffalo, New York. He is a Taurus who travels the world. He is a bisexual (not gay, but still queer), who conducts his life according to the direction of his newest passion.

I met him in 1997 at my master's graduation. He was a friend of a friend, who happened to be driving near San Diego that day and wanted to come for the party. He called to ask if it was okay. I couldn't see why not. It was an excellent decision on my part because I came to learn that Tomás makes a party. He is a stand-

up comedian, who can cause even the most uptight party guest to crumple with laughter. I don't know him that well, but he is always inviting me down to Buffalo to visit. It's time to take him up on his offer of hospitality.

From Toronto I drive around the curve of one great lake and then the other, but it's not until I hit the Peace Bridge that I get anxious about the visit. I sit in traffic, high above the water, teetering between the two countries. Is this a good idea? I really like him and am happy for the chance to spend time together. But once there are other motives, it muddies things up. What if he thinks I'm only hanging out with him because I care about his sperm? What if it makes him feel used? I won't think about that.

It's easy enough to avoid it. As soon as I walk into his 1920s bungalow apartment, he pours me one of his famous Adolfo mango martinis, and puts on the newest important album he's just picked up that I really must listen to. I spread out on his couch under the red velvet wall, chew on a chunk of mango, and relax. Maybe the sperm got me here today, but I'm so thankful for the chance to chill out and recover from another heavy week at work. In my new position as a professor I've got so many classes, so many students, and there's always a crisis to fix. My job's also located two hours outside of Toronto, in a river town called Peterborough. The commute is a killer. It's a good job, but it wears me out.

Tomás soothes me. He clowns for me. He builds his stories up into giant towers and then crashes them to pieces with punchlines. He watches me closely, watches my eyes widen, my back straighten, my mouth drop open as he leads me into a full belly laugh. Sometimes I look up at him at those moments to see the glee in his eyes. He relishes the pleasure he offers me. Occasionally the stories are mean little things, poking fun at people that we shouldn't laugh at, but that makes them all the more enticing. It feels like getting away with something bad. He saves up clever events from his days and prepares them for performances. They're his gifts to me on

every visit. I go the first weekend of every month. He gets me through the term.

(May 2006)

I choose a night in May to ask Tomás. I smuggle fiddleheads across the border for him. He crops them and places them in his pan with garlic and butter. He sautés them carefully, preparing the base of his soup.

He bakes a chicken in the oven, cooks rice on the stove, and plays Shakira on the stereo. I am so thankful to be spoiled that I almost forget to be nervous. He tells me stories about his village in Colombia. His little grandma, who is still alive, warns him to find a wife soon or people will gossip about her grandson and she couldn't bear that. He tells me about the river that runs through the centre of town. The mantlepiece in the living room is lined with stones from the riverbed. "When I was a little kid," he gulps his martini, "I planned to build a raft, grab all my toys and clothes and shit, and coast down the river right out to the ocean." He finishes one martini and gets up to mix another. "There were often threats of violence at that time, but my mom taught me to go to the water." He smiles. "That's where there's life."

I think in this moment that I want his mom and his raft and his town and his dark blue eyes and big bear of a body to be part of my baby. I look up at him and open my mouth, but nothing comes out. It's too early.

By 2:00 a.m. I can barely hold my body up after the chicken and fiddleheads, after the drinks, and after the dancing. We slip all over his hardwood floors, dancing salsa until we collapse right in the middle of the hallway. I can't move, but he motions to me not to bother. He brings over a bottle of Aguardiente and a couple of shot glasses. I brighten up. I love the smooth, warm drink. I sip and let the sweet anise flavour fill my mouth. He goes to pour me another, then pauses.

"Wait," he announces, "I'll give you another, only if you tell me whatever it is that's on your mind."

The blood rushes to my ears. They're hot and throbbing and Tomás points at them and laughs. "Oh, this has gotta be good."

My head feels ten pounds heavier than it should and I'm afraid to ruin our night together. I don't want to lose the joking, the food, or the Aguardiente. I don't want to lose him. What if he gets all weirded out?

He is holding my shot glass captive and raising his eyebrows at me. "Well?"

I blurt it out. "I want to have a baby." I steady my gaze and look right into him. "Tomás, would you help me have a baby?"

He looks relieved. "Oh, whew," he sighs, "I thought something was wrong." He breathes in again, heavily, and out once more. "I don't know," he runs his big hand through his thick curls, squeezing them, "I don't know the answer to this."

"That's okay." I almost want to take it back. I hope I haven't upset him. "It's okay. It's okay," I keep repeating almost like an apology.

"Don't worry," he interrupts me, "I just need some time to think." His smile returns, he looks back at me with a dreamy stare. "What a beautiful thing you've asked me."

Time. Why do these men need time? Just because it's the biggest decision of a person's life. That's all. Time is the commodity I don't have much of to offer. I'm speeding like a rocket toward thirty-five. Thirty-five is the magic number when doctors get to do more tests on you, when all of a sudden your chances of getting pregnant decrease, when babies might have problems. When you're thirty-four, everything is clear and fine. On your thirty-fifth birthday, a single twenty-four-hour cycle later, the world has changed. You might not have a baby. I don't want that to be me.

I give him the summer. It seems fair to offer a whole season. A single intact portion of a year. The season that is heavy with flowers, plants, trees, everything bright green. There is so much vivid life around, shining in the sun. I want him to take it in every day for the next four months and feel inspired to help me out. But that's not what happens.

In September he is just as dazed on the topic as the night I told him. He is amazed by the question, in his own state of wonder. It is his private dreaming, he explains. Our little baby is the secret he thinks about in the extra minutes of a day, when he's driving, waiting in line, showering. He cannot tell me yes or no. He doesn't know if he'll ever have the answer for that. He's not ready to make such a commitment, even as he has loved imagining it. He's aware that this response means that I'll have to move on.

I can't be upset with him. I could never be upset with Tomás. He hugs me, soothes me once again. Even as he turns down my offer, he makes me feel a part of his poetry. Our make-believe baby holds a place in his imagination. She's been in his dreams for months now. That counts for something.

. . .

I lose my nerve after Tomás. I can't continue investing so much of myself in these guys. It's too dramatic. It's too hard. I need a new approach.

The inherent flaw with my strategy to acquire sperm has been a lack of open marketing. The only two guys who know I'm trying to get pregnant are the two who can't do it. I've been too shy, too secretive to cast an adequate net. It's hard to find someone when nobody knows I'm trying to get pregnant.

There's a reason for my reticence. I don't want to be the woman everyone feels sorry for. I imagine people pointing as I walk by,

whispering to each other, "You know, she always wanted to have a baby."

"Poor thing," the other lady answers.

I don't want to appear lacking. This persona doesn't go well with my calm, together exterior. I hope to avoid it. It could, in part, explain why I have so far chosen guys who live out of town. I don't have to face them on my streets, and think about my unfulfilled dream.

But if I really don't want to be the woman without the baby, I need to change course, and open up the potential pool of sperm. I'm not talking about a free-for-all. I don't want everyone to know. I still want certain boundaries, a degree of compartmentalization, a bid to my paranoia of perception. For example, I want to be able to go to work and be a professor, and not a dyke looking for sperm. I want to perform at public readings and not have an audience worried about me. I want to be a valiant community activist and not an incomplete woman. I will only ask acquaintances, friends of friends, people I don't deal with on a daily basis.

The quality of the search deteriorates rapidly from here. The list of ideal attributes in a father is reduced to the superficial. The kind of meaningful relationship I have hoped for is gone, replaced by little more than speed dating.

Joel works out, has a square jaw, and hazel eyes. He's a psychotherapist friend of a psychotherapist friend. I'm guessing he is therefore both intelligent and in touch with emotions. He is a Chilean gay man in a relationship, looking to have children.

Hilary and I ask him for his sperm at a potluck. He and his boyfriend respond that a shared custody situation is out of the question. He came from a broken home, he answers, and doesn't want to force another child to go through that.

I find the explanation confusing. Are four queer parents living in two houses the same thing as a broken home? Will his plan for a surrogate mother be any less broken?

Trent is sweet, smart, and pretty. He's a lawyer friend of a lawyer friend. He's pretty the way only a gay man can be, with sparkling blue eyes, blond hair a little too long and layered, and dimples on both cheeks. The rejection is more straightforward than with Joel. He's just not up to it. He's fearful. "Imagine the paternity liability for the next twenty years," he gasps. "Nothing personal."

There is a man at the neighbour's party with a clever sense of humour, a charming guy on an airplane, a professor from Alberta. The rejections pile up and Hilary notes that we've entered into some awful movie about asking out dates to the prom. I hit on all these men, but the answer is still no.

. . .

I drive my blue Toyota out beyond the strip malls of Toronto, zigzagging into the country. I sing along with Johnny Cash, watching rows and rows of corn and soybeans. I pass Tim Hortons and farming trucks and boats on trailers. I drive until the land opens into a mass of water. Port Perry always surprises me. It could be a marina on the California coastline, but here it is, right in the middle of the farming fields of Ontario. I drive farther to a small school made of bricks and steel. This is where I will work for the day. In my position as a professor of education, I drive all over the countryside to visit my students as they practise teaching. I pull my Guadalupe medal out over my shirt, and zip up my blazer. I ruffle my hair and check the polish on my shoes. Inside I find my student in her placement classroom, leading the children in a song circle. I observe her teaching, offer her tips, schmooze with her teacher mentor.

At 4:00 p.m. I take off down the road again, starving, in search of lunch. I come upon Veracruz Mexican Restaurant tucked back near a cluster of trees, a half block from the water. When I enter and smell the chili and garlic, I want to cry. It's not one of those pretend Mexican restaurants catering to the unknowing Toronto crowd.

These owners are direct from México. "We're from Guadalajara," announces the waitress when she gives me the menus. I thank her for that.

There is another patron in the booth next to mine. He is a young man with black hair and brown eyes. He catches my gaze, and smiles. He overheard my exchange with the waitress and adds that his family is from Monterrey.

"Mine is from Chihuahua, but from a hundred years ago," I answer.

He compliments me on being a fellow northerner (northern México).

Mexicans are everywhere in the world, but sometimes it can be hard to find each other. You can go days and days in Ontario without seeing another one.

"Where do you live now?" I want to know.

"Cobourg."

"Cobourg?" I ask.

A Canadian from Cobourg found him in Monterrey and brought him here to marry.

"Funny thing," I say, and explain that one swiped me from San Diego.

He and I spend a lot of time talking about the food in our fantasies.

"Tacos barbacoa," he pleads.

"Enchiladas . . . menudo," I counter.

Our faces twitch with the pain of it.

I share the taste of food with him and wonder about his sperm. It would be good, rich sperm. I wish I could have just a little bit of it. I can't imagine that the Cobourg fiancée would be willing to share. I bid him goodbye.

I climb into my car, but can't bring myself to leave. I gaze past the restaurant to the lake opening wide into the horizon. *Okay. Enough already. This is too much.* I can't be driving across the Canadian countryside with this kind of hunger. It's desperate. I won't be a desperate woman. I can't be so dependent on men. I didn't become a lesbian to have to turn around and hold my hand out for a guy to notice my worthiness as a mother. I don't fucking need men. That's not the life I've chosen.

But the feeling of failure is overwhelming. I don't want to be a joke. A queer joke. A woman who is too butch to get a man. I can't get over feeling like if I don't get a guy to give me sperm, I've somehow failed. I am too queer, too butch, too ugly.

When I was twenty-one, I was in love with my first girlfriend. She had long brown hair, green eyes, the highest cheekbones, dark red lipstick. She was a gorgeous femme, and I was in awe of her beauty.

Maybe I made some remark about how different I was from her as a butch.

My mom seized on my insecurity and exclaimed, "You know you are pretty, right?"

"Of course, I do." I took the challenge as an insult. It seemed like she was saying that my lesbianism had something to do with not knowing I was pretty. (You have to understand that I was fairly newly out and as such still convinced that everything around me was homophobic.) Besides, it was more convenient to turn her words away from me. Because the truth of the matter was that I didn't know I was pretty. And I only vaguely know it today. And I know it less after each rejection. I shouldn't have to find sperm to prove to myself that I am attractive.

I try to reassure myself. I search for my confidence. Being a lesbian is about choice. I choose women, not because I can't get a

man, but because I fall in love with women in ways I've never felt for a guy. I've made love to beautiful women who won't let men lay a finger on them. But they let me.

I think about what Hilary tells me when I get depressed about all these guys and their protected sperm. She's convinced that anyone can get a man. There's no achievement in this. But what I need is more challenging. "Men are basically up for sex most of the time," she asserts, "but it's very difficult to find one who wants to have a baby." It doesn't matter what your sexuality is. They don't want to have babies with straight women either.

The fields in the distance change from green to grey in the dusk, until there is only a burgundy outline where the sun falls behind them. The small ripples of the lake disappear into the darkness, but I can still hear them lapping up against the rocks. It's getting cold. I turn on the motor and pull back out onto the highway. I press the accelerator and speed across country road 7 toward home.

It doesn't have to be this way. As much as I have wanted a father for my little baby, it's not a deal-breaker. I won't lose my chance to get pregnant. I'm not waiting until all the men and their boyfriends feel comfortable enough to create life. I have a paycheque. I have the Internet. It's time to give up on the guys. It's time to shop.

6. Caviar

Toronto (October 2006)
11:37 p.m.

I am in the tall, red office chair clicking away at my girlfriend's computer. I'm in the driver's seat. I've somehow managed to plant my ass in it for this most important mission. My girlfriend sits beside me in a small folding chair. The large screen in front of us illuminates the room. I could've hidden away on the third floor with my computer, but most major family decisions tend to get sorted out here in her little office, with continuous Internet access, adjacent to the kitchen, the nexus of our home. The cat jumps onto the desk, circles into a comfortable position, and flops down with one paw across the keyboard.

Carefully avoiding the thousands of sperm sites devoted to stallions, canines, and other needy farm animals, I find those intended for human beings. There are three sperm banks available to the Toronto market. There is a combination of American and Canadian sperm for sale. I anticipate the tedious work of sifting through hundreds of donors, only to find fewer than forty at each site. Surely there are millions of Americans to choose from. How can there be so few on these websites?

As if it were a peach stamped at the border by the customs agricultural authorities, the sperm also receives a thorough inspection. It's either "Canadian compliant," or it's not getting in. Apparently Canada has higher standards, more rigorous testing of sperm. No riff-raff sperm allowed above the forty-ninth parallel. Out of three hundred million Americans, only eighty-one consent to jerking off (and undergoing the extra tests) for their Canadian cousins.

That's okay. I've always been overwhelmed by too many product choices on shelves. A hundred is a more manageable number. I click and scroll. Every height, occupation, aspiration,

and medical history is at my fingertips: black hair; brown, wavy hair; blue eyes. Architect, PhD (note: PhD sperm costs extra money), 6'3", likes soccer, politics, 170 lbs, small-medium bone size, stock broker, engineer, Bulgarian, medium-large bone size, MBA, 5'8", Jamaican, baldness, Irish, blue-grey eyes, fair skin, friendly outgoing, friendly outgoing, friendly outgoing . . . Are they all friendly and outgoing? And who decided that this was true about them? Was it self-reporting? Did they flirt with the nurses? Do we want all of our donors to be extroverts—if it's genetic, think of all the attention that will require? Are the sales down for introvert sperm?

I've been to school too long to enjoy sperm marketing, not that I don't still fall for it. *Likes politics, tennis, speaks German.* I wonder about the bias and motivation of every description. What is it that the clinic thinks I want to hear? What power did the man hold in determining his own brand? Does he lie when he describes himself? How does it feel to be sold off bit by bit to anyone with a computer and a credit card? And what do the men have to prove to be worthy of sale? No criminal record, no history of mental illness, no gay sex.

No queer sperm allowed. It's the law. Just like there are no queer blood donations allowed. It doesn't matter how safe a man has been, his sexuality eliminates him from fertility clinic procreation. I don't believe in the danger of HIV anymore, I think it's just an excuse to stop queers from producing children in every possible realm. Sadly, I gotta let go of that trait from my list of the ideal sperm donor in order to move forward. I can live with that. Ethnicity is what's truly most crucial to me. I want a Mexican man.

I scroll and click.

Race: Caucasian; hair: blond; eyes: blue.

Race: Caucasian; hair: light brown; eyes: green.

Race: Caucasian; hair: light brown; eyes: blue.

Race: Asian; hair: black; eyes: brown.

Race: Caucasian; hair: brown; eyes: hazel.

Race: Caucasian; hair: blond; eyes: green.

You have now entered sperm bank land, where Caucasians once again reign. It hasn't changed much from the eighties when my mom sent away for those pamphlets. There is some diversity. There are a couple of Asians, a couple of black men, and a couple of Latinos. There are tons of white guys. If you're not white, it's like Noah's Ark for you: two of each ethnicity permitted on board. I wonder if they congratulate themselves at the clinics, "Hooray, we've got two Chinese guys, we can move on now."

Even the Latinos identify their race as "Caucasian." I shake my head. That's nothing new. The race category has never worked for mixed-race Latinos. In fact, I probably get more insight about the politics of the two Latinos through their responses to "ethnicity" and "race" than I do from anything else written about them. I am most impressed with the one who defines his ethnicity as "Mestizo," and least impressed with the one who calls himself "Spanish." Self-proclaimed Mestizos probably understand and have some pride in both their white and indigenous roots. Self-proclaimed Spaniards know that being "Spanish" sounds a lot better to Euro-Canadians than any of these shifty Latin American national identities. That's a point for Latino #4228 and his anti-colonial sensibility.

Actually, #4228 seems pretty good. He's in graduate school and working part-time, and Hilary and I agree that there's a lot of potential. His mom is a doctor and his dad is a lawyer. Those are smart genes. He's got dimples too, and speaks three languages. He likes soccer and movies, and believes in God. He used to play the saxophone in a band and wants to improve the environment. There's no major illness in his family, though it seems his sister was born with three kidneys. I didn't know you could be born with three kidneys, that there's room inside to accommodate that sort of thing.

I look at Hilary with my eyebrows raised in a question.

Hilary shrugs, "Could come in handy."

"That's true," I nod.

"Spanish" Latino #5279 likes to work out and used to be a member of his school's debating club. He is a computer specialist and writes software. He wants to design a new program that will revolutionize word-processing. He also believes in God, but does not currently attend church. He likes playing dominoes and going bicycling. Science was his best subject in school and he has good teeth. There are no major illnesses in his family, except cancer in one ninety-year-old ancestor. If you make it to ninety, I figure you've already beat the statistics and the cancer shouldn't count against you.

I like #4228 the best. He's got the arts, he's got some politics, the dimples, and the smart genes. He sounds like someone I'd hang out with. Number 5279 seems too serious. Too left-brained. I don't know if I'd ever hook up with him if we were in school together, or at a café, or even a bar. I do want someone that I'd have a chance of hooking up with outside of spermland. I don't know why, but I have to be able to imagine him and me meeting up so that something about this process feels natural.

Okay, I've neglected one glaring detail. Height. My Aunt Janie's only advice to me was that I should pick a tall father. It's her sole criterion. She always felt that my grandpa, standing at only 5'5", had a hard time of it. When she tells the story of her own marriage, she emphasizes a single pivotal moment: the time she first noticed her husband's tall, lanky body through an office door and fell in love.

Number 4228, my sweetheart, who's working his way through his graduate degree while he flirts with women in the library in three different languages, is only 5'5". Number 5279, who forgot

to eat lunch today because he was so sucked into his computer programming, is a respectable 5'9". Shit. I never bought into my aunt's height theory until this very moment. I'm only 5'2". Five-two plus 5'5" doesn't add up to much. Didn't I read research that said tall people get paid more? Is it a superficial consideration, or am I deciding my baby's future employment opportunities?

There's another complication in my sperm donor decision-making. On the form, they require my top three choices. Two Latinos, but three choices. How weird to be asked for three choices. As if I'm signing up for workshops or something. If I can't get into the digital narrative seminar, then send me over to philosophy of education, or even mathematics manipulatives. Any one of these three will do the trick. Will they tell me which one I get to have, or is it the kind of game where you don't find out until you're warming up the sperm for insemination?

I let Hilary claim number three. She finds a Jewish actor. He has brown, curly hair and green eyes. He loves his mother and enjoys camping. He wears a diamond earring and plays the guitar. He only speaks English, but always wanted to learn Italian. His favourite ice cream flavour is pistachio, and his most painful memory is sitting in the car when his parents told him they were getting a divorce. He's our wild card.

Hilary's a sucker for the sensitive boys.

. . .

I can purchase sperm at a moment's notice, but I need a doctor in order to receive it. Resources. Get resources. There are people who can help. I don't need to figure this out on my own.

First I get a therapist, who happens to be a lesbian mother herself. She is an expert in helping people solve problems. She is also a member of the lesbian mafia, a broad network of lesbians who keep the city running. She knows who does what. She knows the doctor who gives lesbians access to sperm. She knows the

queer parent advocate at the health centre. She knows that I am undertaking the most vulnerable experience of my life.

. . .

The doctor doesn't wear a white robe. No stethoscope either. She's got short brown hair, glasses, jeans, loafers, and a black T-shirt. She's a dyke. I follow her to her office and we hang out together as if we're in a bar. It's so casual, I feel like she's one of my buddies.

"Email me on day one," she instructs, "then get them to ship the sperm to my office for day twelve."

I write everything down in my notebook. I don't want to mess this up.

"Chart your temperature changes or buy yourself one of those ovulation predictor kits," she continues. "As soon as you're about to ovulate, call me."

"Right. Then what?"

"Well, do you want me to do it?" She folds her hands together and looks me straight in the eye, "Or do you want to do it?"

It's a crucial question. I only know the answer because I've prepped. The therapist had asked me one day if I connected sex to babies.

"Yeah," I replied, "doesn't everyone?"

"Nope," she shook her head. "But since you do, you should probably have some when you're trying to conceive."

It sounded like good advice. It sounded more fun anyway. So I look back at the sperm doctor and tell her, "Thanks, I'll do it myself." With some help from my girlfriend.

She smiles. "So you'll need to come by and pick up the sperm when you're ready." She stops talking and I stop writing. My notebook is full of paper but she's done.

I look up. She's watching me attentively.

"Any questions?"

"That's it?" I say in disbelief.

She nods, "Yep."

I was imagining machinery, cold metal tools, gels, stirrups, exams, blood tests. "I thought it would be a bunch of complicated medical stuff."

She smiles. "Nope. If you don't run into problems, getting pregnant can be easy."

. . .

Getting pregnant via sperm banks requires coordination. I need to ovulate. I have to have enough money in the credit card account to buy the sperm. There must be enough sperm available for purchase. The delivery needs to be timely and accurate. The clinic must be open when I'm ready to transport the sperm home. The girlfriend needs to be home to put it in. The kids need to be entertained away from the bedroom so there's enough time to create a romantic setting for the insemination or, at the very least, to not be interrupted mid-procedure.

I close my eyes and see each of the steps operating in sync, each one making the next move possible. A Rube Goldberg machine. Just to get sperm inside me. If even one step fails, one component falls, piling onto the next and the next one after that, it will render all my effort for the month pointless.

. . .

I decide to save myself the $45 a month cost of the ovulation predictor kits and stick with the thermometer, a one-time charge of $8.95. I photocopy the sample chart from the thermometer box, clear out a drawer in my night stand, and get to the daily work of keeping tabs on my body. 98.0. It's the opposite of my job, where I am paid to focus on my mind. It's new for me.

It doesn't seem like a big deal, a simple temperature check once a day. But it's cumbersome. It's hardest when I'm most exhausted. I can't entirely let go. I can't say, "Okay, I have no commitments tomorrow, so I can go ahead and sleep as long and as deep as I want." If I did that, then I wouldn't remember to take my temperature in the morning. 97.9. Because the way it works is that you have to take your temperature when you wake up, before you do anything else: before peeing, before drinking any water, before putting on your bra, before sitting up. Any significant movement could alter the reading and wreck the chart. 97.5. Therefore, the thermometer must be placed within reaching distance of the sleeping position. 97.7.

I don't want to spend my first moments of every day monitoring my body. I don't want to spend my nights worrying that I won't remember to do it. 98.1. It can't be good when you're trying to relax and get pregnant.

I discipline myself. I take my temperature carefully and thoughtfully every day, for two months, but my numbers don't add up to anything. There is no clear sign of the sudden rise that follows ovulation. There is no obvious indication of when to email the doctor and let her know I'm ready. Maybe it takes months of charting to see a pattern. On the third month, we guess.

Guessing is especially tricky with frozen sperm. There aren't as many, they don't move around as fast, and some people say they don't live as long. They need to hook up with my eggs, which have only got a twelve- to twenty-four-hour window once a month. If they don't cross paths at the exact right moment, I gotta wait another twenty-nine days.

. . .

From: Karleen Pendleton Jimenez
Sent: Mon 11/12/2006 11:02 PM
To: Jamie Silver
Subject: day one

Hello Dr. Silver,

As you have asked, I am emailing you on day one.
This was a little earlier than I had expected. But I guess I don't
really have the hang of this yet.
Last month, day one was on November 12th.
I think now you will let me know when to start ordering sperm.
I went in for the blood work today.

Questions:
Is there any other info that I need to give you?
Did you say that I should no longer be cleaning the cat litter—or
is that once you're pregnant?

Thanks,
—Karleen

. . .

From: Jamie Silver
Sent: Tue 12/12/2006 1:03 PM
To: Karleen Pendleton Jimenez
Subject: re: day one

Hi Karleen. Sounds like you're ready to go for this month. I
would guess that you ovulated around day 15 last month. That
lands you on Christmas day for this month. The only problem
is that I will be going away on Boxing Day. Did you still want to
try it yourself? If not, we will have to wait until next month. I
hope this is not too disappointing. If you take it home and do it
yourself, you need to order unwashed/standard sperm.

What do you think?

Re: the cat litter. I would make this decision based on how your partner feels about changing cat litter. If she doesn't have a problem taking over, then she should start once you've been inseminated. If it takes a long time to get pregnant though, she might get irritated. You should begin taking folic acid starting now.

Let me know what you'd like to do.

—Jamie

. . .

From: Karleen Pendleton Jimenez
Sent: Wed 13/12/2006 1:37 AM
To: Jamie Silver
Subject: re: re: day one

Dear Dr. Silver,

Yes, I would definitely like to go ahead and do the insemination myself.

P.S. Unwashed sperm? That sounds a little gross.

—Karleen

. . .

From: Jamie Silver
Sent: Wed 13/12/2006 8:30 AM
To: Karleen Pendleton Jimenez
Subject: re: re: re: day one

Hi Karleen,
You should order 2 standard (unwashed) vials of semen to 475 Bloor St. for Friday, December 22nd. The washing sorts the sperm into the most viable product. I assure you that it has been rigorously tested and is "clean." I can meet you on Christmas

Day to give you the tank to take home. The tank will need to be returned by December 29th.

While there is no meaningful shift in temperature to signal ovulation, your 29-day cycle probably means you're doing it around day 15. This is because a normal luteal phase (the second half of the cycle) ranges from 12–14 days, and we can count backwards from the day ones. We'll shoot for December 27th for insemination. Keep charting your temperature. I suggest you switch to OPKs (ovulation predictor kits) for next month.

Does that sound fine to you? Questions?

—Jamie

. . .

From: Karleen Pendleton Jimenez
Sent: Thu 14/12/2006 5:13 PM
To: Jamie Silver
Subject: re: re: re: re: day one

Hi Jamie,

That's great. I'm very excited and ready to go.

—Karleen

. . .

From: Jamie Silver
Sent: Fri 22/12/2006 8:47 AM
To: Karleen Pendleton Jimenez
Subject: re: re: re: re: re: day one

Hi Karleen,

I have a family emergency. My grandmother in Montreal has had a stroke. I'm flying out tonight. I can't be there to give you the sperm.

1) What date is the tank being shipped?

2) Would it be ok to skip this month?

3) If the tank has not arrived yet, I think it is best to wait. I won't be able to give you any instructions.

4) If it has already arrived, I can have a nurse meet with you to discuss the procedure. Would that be ok?

What do you think?

I'm so sorry, I know you are very much looking forward to begin trying.

—Jamie

. . .

From: Karleen Pendleton Jimenez
Sent: Fri 22/12/2006 12:41 PM
To: Jamie Silver
Subject: re: re: re: re: re: re: day one

Dear Jamie,

I'm so sorry to hear about your grandmother.

I really want to start this month and the sperm has already been ordered. Don't worry, I'll figure it out with the nurse.

—Karleen

I'm supposed to be Christmas shopping. I'm walking around the Eaton Centre, sucking up the ventilated air and loud buzz of voices. Nothing at the stores seems like the right gift. I like to watch the expression on a face at the exact moment the gift is revealed, and it's perfect for the person. The mouth drops slightly open in disbelief. Or it's a let down, and there's a quick, half-curled grin. It's always risky. Today there are no perfect matches and I'm walking

in circles and I've just about reached the point of mall saturation. And worse than failing to check off any person on my list, I can't seem to get sperm out of my mind.

Each day I open my email anticipating the collapse of my plans. I recognize that the doctor is a human being. I care about the fact that someone she loves is seriously ill and that she needs to be in Montreal with her. But I don't want to. I don't want to be patient and understanding. I hadn't calculated the grandmother into the list of potential pitfalls for my insemination. They can come at you from any direction. Before I've even begun, I'm ready for it to all go wrong. *Ugh.*

Don't think about it. Hilary says don't think too much. It's harder to get pregnant if you get all obsessed.

· · ·

I have to prepare myself just in case things do work out. I need equipment. Not what you've heard. In fact, at this point it's probably best to debunk the turkey baster myth. It's a misunderstanding. You could do it, but it's not optimal. It's too big, too hollow; the stuff could get lost, scrunched up in the rubber at the back. It might never squeeze out through the hole. And you don't want to waste any. It's liquid gold. Five hundred dollars for a few drops in a tiny plastic capsule that looks like a bullet. Maybe they used to give you more sperm in the days when the turkey baster became synonymous with lesbians. Maybe they had fresh stuff. But I'm telling you, once you've looked at the price of sperm, you won't be willing to waste any at the back of a turkey baster.

It's best to use a plastic syringe. A thin, long tube. The doctors have the best ones. Pharmacies carry adequate one. Every ounce pushed inside. Millions of little guys in every drop.

Then there's the question of ambiance. How do you set the mood for a Thursday morning insemination? A candlelit dinner won't do. We cross town in pursuit of our sperm tank while

everyone is rushing off to work. I'm tired because I'm not a morning person. Hilary is gleeful because she is. She drives swiftly down College, edging her way past trucks and left-hand signals. I halt her trek when I spot a café and demand a pit stop. I run across traffic and order lattes and croissants. I return to the car with my offering. I hand over the sweet, warm drink and buttery pastry exactly how she likes them. She smiles at me. It'll have to do because it's all I can muster.

. . .

When we arrive at the clinic the nurse hands over the sperm and the instructions. The sperm comes inside a big, grey box with a handle. It's heavy and awkward. I try to hold it up and out so that it doesn't bang against my knee when I walk. It reminds me of when I was a teenager carrying around a French horn. I wasn't strong enough then and I'm not strong enough now and it wobbles and hits my legs. I especially want to hold it up for the twenty feet required to get past security at the front door of the clinic. A butch acquaintance of mine works there. It's bad enough to be spotted carrying sperm around, at the very least I could hold it with some dignity as I pass her.

I hope she doesn't tell anyone. I know doctors have to keep your information confidential, but are hospital security under any obligation to keep quiet? I don't really want butches to know I'm trying to get pregnant because I don't want them to make fun of me. I don't want them to see me as a lesser butch either. And I don't want to feel like a lesser butch. The idea of getting pregnant is revolting to a lot of butches, right up there with wearing a dress. I don't know why I want to get pregnant while at the same time there's no way in hell I'd wear a dress. It's what feels right.

I'm not being paranoid. I was having a beer the other night at a bar in town when another butch started talking about pregnancy. Seems a buddy of hers got pregnant. She shook her head in disbelief

while she was telling me about it. Anyway, she developed this scale of butchness from androgyny (1) up to ultimate butchness (5). She rated herself as a 4.8 and her friend as a 1.2, then swigged down her beer. "The femmes are supposed to have babies," she declared, "not us."

I should have spoken up. I should have told her that I was trying to get pregnant. I should have defended her buddy, given her another way to look at the matter. But I didn't say a damn thing. I don't want to be a 1.2. Even if I know she's full of shit, there's still a part of me that believes it. Don't you love internalized misogyny? What if I never get pregnant but because they know I tried, I'm automatically relegated to the lesser butch category. I'm not ready for that. I love my masculinity.

I love it when I strut down the street and get the disapproving glares from straight people. And I especially love it when I'm making out with girls. There's something really hot about masculinity in lesbian sex, even though we're not supposed to admit to it. Maybe *because* we're not supposed to admit to it. Pretending to be a man in bed might turn your lover on, but it could be perceived as a betrayal of the sisterhood. Outsiders may think it's indicative of an underlying heterosexuality, a desire to switch back to men, but they got it all wrong. The masculinity is sexy precisely because a woman is doing it. It's the queerness that makes it irresistible.

There's a whole line of products to support the fantasy: dildos, harnesses, lube, condoms, porn. Today, we add sperm to the list. It's the most expensive sex toy I've ever purchased at $500 for a few drops. It's the caviar of sex toys. (Hilary says it smells like it too.)

. . .

We secure the tank in our car with a seatbelt and head home. It is two days before I turn thirty-five. Hilary leads me upstairs to our bedroom, and closes the door behind me to keep out the cats (the kids are at their dad's house). She pushes me up against the

wall, and grabs my wrists tightly in her hands. She kisses my face and my lips. She brings one hand up over my breast and rubs. She forces her thigh between my legs. I may be the butch and she the femme, but she's stronger than me and can take me down any day.

Just when I can't bear her hands all over me a second longer, when I know I need her inside me, when I'm desperate and wet, she raises her finger to her lips and gently quiets me, "Shhhhhhhh," she pauses, and whispers, "You're going to have to be patient." She motions for me to lie down on the bed.

On the top of her nightstand, she reaches for a pair of black winter gloves. She slides them on, sits down next to me in bed, and pulls the big grey tank toward her. She unlatches several silver clasps and opens the top. She unscrews the lid, and grabs the long metal rod that resembles a ladle. As she pulls it up, the smoke from the liquid nitrogen spills over the top of the tank and lingers in the air around us for a couple of moments before it dissipates. There are two bullet-shaped plastic capsules stuck to the rod in little holders. As instructed by the nurse, Hilary grasps one in her glove and abruptly snaps it off. She lowers the rod with the other capsule back deep into the tank.

She warms the capsule in one hand while she resumes caressing me with the other. I check the time. 11:17 a.m. The doctor said wait at least ten minutes for the sperm to thaw before inseminating, but no more than twenty. I close my eyes and try to forget about the clock. I focus on her hand tracing over my stomach, then across my hip bone and down my thigh. I shiver. Hilary squeezes and tugs at me until my skin is pink and warm. She pets my thighs before she works herself inside of me.

I lift my head, and catch a look at the time, even though she is making love to me. 11:29. I don't want to interrupt her, but I start to worry. "Babe, don't you think you better do it?"

She cuts me off with her lips kissing mine, and then pulls back. She sits up on the bed and opens her hand. She unscrews the tiny capsule. She sniffs it and wrinkles her nose, "Yep, this is the right stuff." She reaches for the plastic syringe on top of the nightstand. She proceeds quickly and with precision, sucking up every drop of the sperm. She holds the syringe above me and prepares to insert it into me.

I look into her eyes and breathe deeply. I'm scared. All of a sudden I feel like a little kid, not ready for the consequences of this action. I push my hands down and block her from entering.

"Wait," I plead, "I'm scared."

11:32. She is still holding the sperm above me. Her clear blue eyes and dark pupils look right through me. She tells me with all the confidence in the world that everything will be okay, but that she needs to do this now.

I believe her. I believe her certainty, and her strong hands. I believe that she will take care of this moment, and that she will take care of whatever happens to me. I believe her and I move my hands away.

She pushes in and I feel safe under her weight. I am filled with the sperm that she has placed inside me. I am small and I belong to her.

how to get a girl pregnant

7. No Lattes

It's 6:00 a.m. on a January morning. My first day back to work after the holidays. I walk down Bay Street to catch the bus. I am covered in a fluffy down coat. My backpack's stuffed with books, but it's not too heavy. The sky is dropping little flakes of snow that stick to my cheeks, but it's not too cold. Even though I'm not a morning person, I love the city dark and quiet before dawn. It feels like an empty theatre. Years ago my buddy in San Diego managed a movie theatre and we would run through the aisles and dance in front of the screen before the doors opened. The only other people awake at this hour walk by quickly, looking straight ahead or down at the sidewalk. Nobody is ready to interrupt the privacy of the early morning.

My legs are still warm under my jeans as I stroll down the street. I am in such a good mood, I'm practically bouncing with each step. There're a couple million sperm inside me, a couple million swimming, darting in different directions, searching for my egg. I hold them inside me. I protect them. Maybe they'll live just long enough to make my baby.

When I arrive at the terminal I find two dozen others standing patiently in line before me. They wear big shapeless coats and hats as well. There's very little you can see of a person in a Canadian winter. I can make out noses, lips, eyes, a few inches of skin, their height, perhaps how much money they spend on jackets, boots, gloves, bags. That's all. I check the crowd for a short man, say about 5'5", 162 lbs. Mr. 4228 (yes, for the time being I choose the Mestizaje over the height), do you happen to be here this morning? There are two possibilities: one is standing a few feet ahead of me, the other is all the way up at the front. I am only guessing though, because gender is also not so clear, not in big winter coats, and not in Toronto.

The one closest to me turns in my direction for a moment. He has light brown skin that could be described as the "olive/medium" from the chart. Under the pale yellow lights at the station I can't see anything else though. He could be Aboriginal, South Asian, Caribbean, Latino. He could be half the world. I won't know for seven more days if Mr. 4228 will be the father.

. . .

I feel joy in every one of the seven days. I am on a high more smooth and sweet than the best buzz. Until I pee on the little stick, my fate is open, it is hopeful. I tell myself that it doesn't matter if it works this time, it only matters that I've started trying. Even straight people with a steady supply of fresh sperm can take a year or two, even though in my heart I feel it'll be less. For two reasons, it'll be less: 1) I've never felt so certain about anything in my life as much as I do about getting pregnant and becoming a mother, and 2) I'm Mexican and we know how to make babies, stereotype or no stereotype, we do that well.

I won't speak these words aloud. My confidence could be perceived as arrogance by the universe. I don't want to tempt fate, learn any lessons, or dare the spirits to stop me. All I want is my baby.

I keep telling myself that it doesn't matter if it works this time. On the appointed morning I tear open the cardboard box and the little plastic wrapper and try to pee on the stick (I pee all over my hand, shifting the stick up, down, around; I can't see anything, but after a while the white plastic contraption does appear to be wet), then I wait the minute for another line to cross the first, to develop before my eyes like a Polaroid, to reveal evidence of life. And it doesn't. No plus sign, no addition to my family, no matter how many minutes I stare. I continue telling myself it doesn't matter if it works this time, only I find myself feeling like shit.

It was better before I took the test. I could pretend. I could see my little baby girl looking up at me with almond-shaped eyes and a toothless smile. She waves goodbye and disappears, and I'm sitting on the toilet all alone in the white bathroom with my boxer shorts crumpled around my ankles.

My eyes flood and I try to convince myself to stop feeling, so that I can make the trek back down the hallway to our bedroom and deliver the news to Hilary without looking too pathetic. There's nothing to be worried about yet. It would've been incredible luck to get pregnant on the first try. I don't need to have that much luck. It's okay.

· · ·

For the next try I give up on the whole temperature business. I'm buying the OPKs (ovulation predictor kits), and they're going to tell me exactly when I'm about to ovulate. *Right.* If my cycle length is twenty-nine days, then I am instructed to remove the foil wrapper, take off the cap, and assemble the test for day twelve. I have to pee on it just like with the pregnancy test. I will be peeing a lot onto little sticks, one a day for five days, and then another in two weeks for the pregnancy test.

Do people really have such good aim for a five-to-seven-second immersion in a stream of pee? What if I don't have five to seven seconds worth of pee? What if I miss the stick for the first few seconds and don't have enough to cover the rest? *Nope.* I find an old jam jar in the recycling bin and establish it beside the toilet as my pee holder. It's a bigger target.

No peeing for four hours before the official test.

No excessive drinking of any kind.

No variation in the time of day the test is taken.

I choose morning. I pee in my jar every morning and then submerge the stick. After twenty to forty seconds, a new line is

supposed to appear beside an existing line. The new line must fill in darker to signal a surge in my LH (Luteinizing Hormone). LH surges occur twenty-four to thirty-six hours before ovulation. LH is the key. LH is everything.

There's Hilary and me lying on the bed, leaning over our little OPK: forty seconds, three minutes, seven minutes, watching for the prominence of the new line. She squints through her reading glasses. I grab it and hold it five inches from my eyes. If I hold it closer will the line look darker? What if the line is exactly the same darkness as the first? What if it's a little less? Are those throwaways? What if it never gets darker? Do I call Dr. Silver or not? Or let it go? Do I waste $150 in sperm shipping if the line isn't quite there? Do I waste $500 more for the sperm if I use it on the wrong day? I mean, I must still be ovulating, line or no line.

"Shit, babe," I say, exasperated. I've studied the form and texture of the line for so long that I can't see it anymore. "What do we do?"

She holds up the white plastic contraption again, searching for the answer, but there are no solid lines, only a greyish smear. So much for science. "I don't know," she answers.

In the end we decide that while line #2 is not as dark as line #1, it has faded since yesterday. It has already hit its darkest mark, and I'm probably ovulating right now. I call Dr. Silver's cell and we race over to the clinic.

There are no lattes or romance on trial #2. We're too stressed out. I strap the seatbelt around our big grey tank and look at him. He almost seems human in our backseat, sitting up straight and ready for the ride home. He's not the man he used to be. In the month of waiting since the last trial, Hilary convinced me to switch to #5279 and all the height of his 5'9". It is perhaps my most superficial maneuver yet. I've sold out for height so easily. But what if Aunt Janie was right all along, and I have nothing to offer

but 5'2"? And Hilary seems pretty certain. And he's still Latino, the only other Latino.

When we arrive back home I lug Mr. 5279 onto the porch and sit beside him. Hilary asks me to stay put. Sensing a photo op, she retrieves her camera and starts taking photos of me and my big grey box. I try to look brave and proud beside him. This may be all the baby gets to see of its biological parents together.

But when she shows me the images later, I look tired. My serious gaze is nothing but a frown. My hair is messed up on the left side. The grey box looks haggard, scuffed, beaten up from so much travel. The tape and receipt are half torn. Only the silver snaps shine.

I don't get pregnant this time either, or the next, or one final try at home. Dr. Silver refers me to a fertility specialist. I refer myself to a night at the bar El Convento Rico. I figure it's important to keep my options open. There are after all a number of ways to acquire sperm. I go out for the night and dance with a pretty man to prove that I can, that I'm not dependent on the doctors. But that's as far as I get. I've got no idea how to seduce a man, nor am I ready to really try.

8. Fertility Land
Toronto (June 2007)
Mrs. Brady

I'm sitting in a small office cube tucked away at the top of a Bay Street high-rise. The doctor wears her white coat open, revealing a tan linen skirt and pink blouse. Her name, *DR. AMBER*, is written neatly in navy blue letters on a tag pinned to the coat. She flashes a big, wide grin, too wide, as she welcomes me and explains about the counselling session.

In order to begin the insemination process, I am to attend a mandatory ninety-minute counselling session to discuss my psychological status in relation to DI (donor insemination). My leg bounces underneath the desk, my muscles tense. I have a therapist to take care of that kind of shit. And anyway, what is this? A careful talk about the consequences of sex before we roll around together? Spare me. It totally wrecks the mood.

It's probably a lot more complicated and useful than that, but I already know how blissful I feel when I inseminate, and how crappy I feel when I fail. Bottom line: fertility trials affect my mood. The monthly bipolar cycles cannot be fixed through a ninety- minute counselling session.

Dr. Amber assures me that the session is not a test. I can answer questions however I like. Should I answer about a) the shot of Scotch I drink late at night sometimes when I'm sad, or b) the petty arguments I provoke with my girlfriend when I'm frustrated, or c) the dancing that breaks out in the whole family in the living room on days of celebration? A, b, or c? There is a correct answer, to be sure.

I look down at the floor. There is a bigger problem. While there is nothing really wrong in anything this woman has said to me (nothing I couldn't live with), I don't think I can let her touch me. Her hair is blonde and even, her cheeks rosy and soft,

her voice cheerful. She reminds me too much of Carol Brady from The Brady Bunch. I can't let her inseminate me. It would be like having sex with Mrs. Brady, and not only would I fail to get turned on, it just wouldn't feel right. I can't lie back, relax, and get fucked by her. I'm sure she's a great doctor for everyone who had a crush on Mrs. Brady. I'm sure she's a great doctor for anyone who doesn't think about sex (do other women think about sex during inseminations?), but that doesn't help me.

I smile back at her for the remainder of the wasted half hour and go on my way.

(August 2007)
Fertility Clinic #2

The waiting room is decorated with blond leather couches, fashion magazines, and glass dividers filled with bluebonnets. It's a beautiful and elegant place to get pregnant. Anxious women sit on every side of us. Only three men have bothered to join their lovers. I reach for Hilary's hand and squeeze it. I feel like a righteous lesbian, secure that my woman will stay with me, unlike the men. It reminds me of dancing at a straight event, where hardly any of the women can convince the men to dance with them and, for just a moment, they envy the lesbians, who are all on the floor dancing together. Assholes. Do the men think it's the woman's problem?

Then again, maybe the women don't want them here. Do I want Hilary here? Do I want her to see me spread my legs for doctors and ultrasound technicians? Will she still think I'm sexy after seeing me that way? Will she still think I'm butch? I let go of her hand and sit up.

What do women with fertility problems look like? I have a stereotype in my head: white, skinny, upper-middle class, older, uptight. I think it comes from growing up around a working-class community of big brown women and lots of kids. My stereotype

is the opposite of this. I don't think I've ever seen commercials or brochures or any images of infertility whatsoever. This is secret information without representation. I've invented the picture I hold, ensuring that she looks nothing like me. It's protection. But I'm wrong. There is a South Asian woman with big, heavy arms and a round tummy. There is a young Chinese couple in the corner next to the window, pointing at something across the skyline. There is a tattooed blonde with black leather boots. There is a black woman in a grey business suit, checking her watch. There is a white, skinny woman with blue jeans and a silk blouse. There is a subsection of Toronto and the GTA sitting in a room together.

The South Asian woman and I smile at each other when she catches me panning the room with my gaze. I don't want to be part of this group. I'm hoping for this to be nothing more than a brief visit into their land. Before they make any assumptions about me, I think I should confess that I don't necessarily have fertility problems. I may or may not. I have virtually no fertility history whatsoever. I'm not exactly like them. I'm not like them at all. I'm not really a woman even. I'm a lesbian. I'm a butch. I'm an imposter. Nothing more.

"Karleen?" a short, red-haired woman with a clipboard announces at the front of the room. I am relieved to depart the masses and head to the doctor's office. Dr. Meredith looks over the forms Hilary and I have filled out. She apologizes once more for having sent Hilary a male questionnaire. We had amused ourselves with it, answering probing questions about Hilary's male factor infertility. How many times during the week does she ejaculate on average? Any STDs? Any unfortunately located varicose veins? However, the fertility clinic caters to an urban, politically sophisticated clientele and knows better than to send a male questionnaire to a couple of lesbians. And it's also true that it wouldn't be as funny if they hadn't apologized. If I can't have queer doctors, I definitely want some sensitive straight people taking care of me.

Dr. Meredith asks me everything about my life: alcohol consumption, cigarettes, the age of my first period, the number of days in my cycle, how my mother died, the intensity of pain of period cramps, vaccinations, family birth defects, how often I have intercourse. *Does lesbian intercourse help with pregnancy?* I wonder. It couldn't hurt. I account for my life, providing numbers and descriptions. She uses the knowledge to construct a portrait of me for their files. The number Dr. Meredith likes most is thirty-five.

"You're a young'un," she exclaims. "Thirty-five years old with no history of infertility, this is wonderful." Her green eyes gleam from under her glasses. The clinic usually works with older or more complicated clients. She assures me that I have a great chance of becoming pregnant (and I'm sure I'll be a good stat for their success rates). All of a sudden I feel young and fit for pregnancy.

"And if it doesn't work out?" she raises her eyes and looks to Hilary, "Are you interested in giving it a try?"

Hilary bursts out laughing. In her mid-forties, with two older kids, she has no intention of getting pregnant again. Besides, part of the problem in our relationship is that she and her children are very close, and I often feel left out. "The last thing we need is more of my genetic material around," she concludes.

Dr. Meredith nods, chuckles, and notes our responses.

I like her. She looks me straight in the eye when she asks me questions. They are quick eyes, smart, alert. She has dark red, wavy hair, tied together in the back. She is not skinny or fat, but something soft in between. She reminds me of a girl I had a crush on when I was nineteen. I can open my legs to her.

Day 3

There are new rules to learn. On day one of my period I must call the clinic and inform them of my status. They will note on their charts that I have begun a new cycle and advise me to appear for blood work and ultrasound on day three. I must arrive with a full bladder. The images they obtain on day three provide them with all kinds of information that they use to determine whether it is a viable month for insemination. If the month looks good, then they will advise me to order the sperm on day four. All blood work is to be conducted between 7:00 and 8:30 a.m. Therefore, the first thing to be sacrificed in the name of pregnancy is sleep. (Then money. Then alcohol.) As a result, I acquire a much higher stress level than I indicated on the initial forms I filled out only a month ago.

I am terrified of the ultrasound. I know it involves taking off my clothes, and letting them stick some plastic contraption inside me. A friend of mine told me that it's not as bad as a speculum, that it's not so big, that it's smooth, that there's lube. An info sheet advises that it is a painless procedure. The physical aspects of the exam are not what worry me. I would be reassured if I wasn't so neurotic. I will do anything to make this baby, and this urgency will allow me to overcome the ultrasound procedure, but that doesn't mean it'll be okay.

I check in with the woman at the side counter window. She examines my health card, and asks that I write my name and day of cycle on a list. She requests that I sit down and wait to be called. I nod at her and smile. I join the group of women staking out every corner of the blond couches. This is the hour before work begins. They are wearing crisp business suits, skirts, slacks; reading magazines; listening to iPods; checking their calendars. They are trapped for a moment in this clinic, looking their best, before the long day of sitting at computers and going to meetings, eating lunch, gossiping, making phone calls, and writing emails.

I take out a book to read, but they call my name before I finish the first page. There are several steps to this process and the first is blood work. I go behind the little curtain in the side room and a thin, strong Asian woman takes hold of my arm and tightens a thick rubber strap around it. I hate the sensation of a needle slipping under my skin, but I hate even more the sucking out of my blood. I can't watch. I instruct myself that I better get used to this life. Each month I'll have to endure the needle at least five or six times. Maybe I won't even notice after a while.

I sit back down for a good twenty minutes of reading before they call me again. I squeeze my legs tight and feel the pain of the liquid building up inside my bladder. It's now been an hour and a half since I drank the required quart of water. The woman at the sign-in finally calls my name, and I pick up my jacket and book and walk toward the ultrasound hallway. A tall woman in her fifties greets me with an Eastern European accent, "I am Irena." She has dark brown hair in a bouffant hairstyle, hazel eyes, a long, angular face, lush red lips. She's got round hips, a thin waist, ample breasts, curves so perfect she could be a model in a magazine, and probably was thirty years ago. *Wow*.

She leads me back to a small office with an examining table and computer screen. She directs me inside, but she herself stands at the door. I am a trapped, scared animal in this tiny medical room, looking back at her.

"Is this your first time?" she asks with a heavy, melodic voice that sounds like Zsa Zsa Gabor.

My eyes are big and I nod quickly. Does she make it somehow more special if it's my first time? Does she go easier on me?

"Take down your pants and your panties," she commands, "and I will return." *Shoot*, ascertaining my first-time status only amounts to how much instruction I will need.

I cringe. I hate the word "panties." It makes me think of being a young, vulnerable girl, with some tiny, pink piece of cotton covering me up. I don't wear "panties." I wear boxers, thank you very much. I'm not about to talk back to her though. Irena's tone is clear and certain. She has directed me and I am to comply.

My jeans, heavy with my wallet, keys, money, and belt, fall with a big *thunk*. I remove my boxers and hide them inside my pants. I pull down my shirt to cover up the important parts and stand against the bench. When Irena returns she motions for me to climb onto the bench. I scoot my ass up a long strip of paper towel and stick my feet into the stirrups.

If you're persistent, you can still keep your legs fairly closed, even when your feet are in the stirrups. She has to tell me two times that my legs are not open wide enough. I try to relax the taut muscles of my legs. I grab at the sides of the metal bench and close my fists around the paper and metal. Even though Irena is one of the most beautiful ladies with whom I've ever shared such close quarters, I can't bear to see her face right now. I shut my eyes.

She pushes inside me with precision and force. The smooth, cool plastic device enters deeply, and probes. She moves up, down, left, right, pushing the buttons on the computer, snapping photos of my uterus, my eggs, my dimensions, my chances of getting pregnant this month.

She finishes as abruptly as she began, and instructs me to retrieve my clothing. She disappears, leaving me alone on the examining bench with wet, warm lube falling out of me.

Electrical Cloud

They ask me back on day ten. Seven to 8:30 a.m., empty bladder. I follow Irena to her office and don't need to be told to undress for her. When she offers me my two minutes of privacy, I throw off the bottom half of my clothes and leap between the rolls of paper towels on the examination bench.

Today when she enters me, I grit my teeth and swallow a yelp. It hurts. I'm tender after a night of sex with Hilary. Do I look different between my legs? Swollen? Can Irena tell? I'm certainly not going to say anything.

But I feel guilty, almost ashamed. I don't let anyone inside me, hardly ever, except Hilary. It feels like I'm betraying my girlfriend with this ultrasound technician. That's why I made love to Hilary last night, in the hopes that she could physically reclaim me. And she did, and I cried in her arms. But here again is Irena. Do ultrasound technicians feel anything when they open up a woman? Or do they conduct exams so frequently that they can't feel a thing? Do they sense a woman's vulnerability, timidity? Do they try to enter smoothly? Are they ever rough on purpose if they don't particularly care for a client? What does excellence in the conducting of an exam look like? What are they aiming for? Do straight and queer ultrasound technicians have different approaches? Does Irena know that I'm a butch who doesn't open my legs for just anyone? Does she know that it's a privilege? If I were the ultrasound technician, I would love to have a butch client. I would push all my care inside of her.

My follicle has already reached the size of 1.5 cm, so they ask me back again on day eleven. Anything larger than 1.8 and it will rupture, and the little egg will be on its hopeful way. The precious release. The sperm's gotta already be inside when it falls. They advise me that the insemination will most likely take place on day eleven at noon.

When I see Irena on day eleven, I ask her about her family. I want to know who she is. I don't want us to undergo these procedures in a tense silence. If I can't stop her from entering me, at least I can find out about the person with whom I spend these early mornings. She has a daughter back in Croatia taking classes at university. She is alone here in Canada. I tell her that I came to this country on my own as well, leaving my family back in California. I tell her that I teach at a university.

"In what department?" she wants to know as she probes up and around inside me.

I try to ignore the plastic wand and continue the conversation, "Education."

Irena tells me about her hopes for her daughter to become a teacher. If she ever comes back to Canada, I insist that she look me up and I could tell her about our B.Ed. program. She agrees and seems more at ease. She pushes the keyboard, and finishes taking the photographs. I ask her if she'll be there later today to help the doctor inseminate me. She smiles and agrees to try to come.

. . .

When I (Hilary has a hearing today and can't get out of it, so I bring a book for company) return at noon, there are only two or three women in the waiting area. There is a different mood from the morning crowd. We are all here for insemination. Insemination day is exciting. It's an actual opportunity for pregnancy, not the daily drudgery of cycle monitoring (inspections of our bodies as if they were machines). I walk right up to the main reception area, smile at the young brunette answering phones, and give her my name.

Dr. Meredith appears shortly thereafter with an even bigger smile and a flowery navy blue and white dress hanging beneath her doctor's coat. Her red hair and green eyes glimmer.

"Today's the day. Are you ready?" she asks.

"Yep."

We go into one of the ultrasound offices and she asks me to take off my clothes and put on a blue-green sheet outfit.

"All my clothes?" Each day at the fertility clinic I lose more and more of my privacy.

"Everything but your socks."

I lounge on the bench, naked under the sheet outfit, reading my book (*Born on a Blue Day* by Daniel Tammet). When Dr. Meredith re-enters, she flips the light switch off. The room is dark, except for the light of the ultrasound computer screen, and a desk-lamp behind it. It is part romantic mood lighting, part high tech operations, like the cockpit of an airplane glowing in the night sky. The shift relaxes me, and Dr. Meredith comes closer.

"What are you reading?" she wants to know.

I like that she asks about my book. It makes me feel more human if we can share an intellectual conversation, albeit brief. I tell her about the protagonist, the boy who loved numbers, who could relate to them as intimate friends, while other human beings remained a mystery.

She would like to read it, but first she needs to check to make sure that I have received the correct sperm: #5279. Yes, # 5279. Yes, the tall Latino.

"The reason we're in here is to show you the insemination process on the computer screen," she continues. "We don't know whether it makes any difference to the insemination process, but it's a new technique we're experimenting with."

"Sounds good to me." I want to watch the show. I want to watch a show that takes me away from my body. The terrain inside my body is a foreign land to me, milky swirls of tissue glowing in darkness.

Irena slips into the room to take the photographs, and I'm so glad she's come. I mean, Dr. Meredith's nice enough. She's not too slick or arrogant. She looks like a clever woman who I would talk to on an airplane. But Irena's really the only one I know here. The only one I've spoken to at length. It would be odd to have some stranger ultrasound technician at the last second.

Dr. Meredith directs my feet into the stirrups and pulls out a speculum. When she pushes it in, it hurts me. It's too big and too

long and I think it's a misunderstanding. A contraption made for women used to dicks inside them. And I think, *Oh man, I'm an anomaly as a butch. I have a small hole. There aren't enough of us to mold a tool just for us.* I'm not saying this makes any sense. I'm sure a lot of women could benefit from something smaller. But I forget that, because I feel queer in this office with feminine women, real women. I feel like another kind of animal.

Dr. Meredith observes the muscles across my body turn rigid, and asks if I'm okay. "Does it pinch?"

"No, it's just big."

"You need to open your legs wider," she requests. "Just flop them open," she explains as she approaches me with a gloved hand and a long, curved silver needle.

Now I'm glad Hilary couldn't come. I definitely don't want her to see me this way, humiliated with my legs open. I offer myself up to two feminine women whom I would much rather pin down and make love to. Then again, the only thing saving me at this moment is the fact that they are feminine women. It would be much more humiliating for a butch or a man to be hovering over me in this position. At least the femmes might forgive me for my vulnerability, might feel sorry for me, might see my scared eyes and protect me.

"Do you see it?" Dr. Meredith asks, jarring me out of my internal monologue.

I watch an electrical cloud shoot across the screen, sperm swimming on a path deep inside me.

"Yes." I watch in awe.

· · ·

I feel the hard, thick speculum burning in me for at least a day, but it doesn't feel like a violation. It feels like the soreness of a good fuck. What doesn't hurt, what surprises me, is that a million sperm are swimming around inside of me and I don't feel a thing.

INSEMINATION TAKE ONE

Date: August 21, 2007
Sperm count: 2.3 million (Over 1 million is the sperm-bank guarantee, but the more, the better.)
Motility: 74% (Seems like higher numbers would be a good idea, but unclear.)
Follicle size: 1.85 cm (Between 1.7 and 2.3 is great.)
Estrogen: 693 pmol/litre (Between 500 and 1,000 is good, the higher the better.)
LH: 8 mIU/ml (Already risen and fallen. At its peak it should be over 20—mine was 17.)

Waiting #1

I fiddle with the empty sperm capsule in my hand. I keep it in my nightstand, mixed in with receipts, change, and charms. It reads: #5279 (January, 1995). If I get pregnant with #5279, the baby would have its origins somewhere in a medical clinic twelve years ago. What was I doing twelve years ago? My mom was still alive then. I was with girlfriend #2 in San Diego, studying creative writing. I was dancing at the Flame on Saturday nights with Paula and Julieta, Crystal Waters singing, "From the back to the middle and around again. I'm gonna be there 'til the end, 100% pure love." I wasn't thinking at all about getting pregnant. My baby will be twelve years old before it's born.

Date: September 14, 2007
Pregnancy Test: Negative (-)

Blood

I ride my bike through Toronto early morning fog in my leather jacket. I feel warm and protected in my leather against the wet air and day eight's activities: blood and ultrasound.

Karleen Pendleton Jiménez 73

All of the women who draw blood are Asian. The ultrasounders are Eastern European. The doctors are Britishy. The receptionist is black. Each ethnicity has carved out a niche in fertilityland.

I've made friends with one of the blood women. She is tiny under her white coat, with big, dark eyes and black hair pulled back with pins. I sit in her seat, roll up my sleeves, and plead with her not to hurt me. I make my pleas with an underlying grin.

She purses her lips, "I'm going to hurt you."

"No, no, please don't," I bring my hands together to beg her, "I can't take it."

"You will take it," she smiles maliciously, "and I will hurt you."

I laugh my ass off. It's a game we've got going. It makes the unpleasant ritual much more bearable, especially since she is a master at her job. She drives a silver needle through my skin and into my vein, and it's so smooth. It feels like nothing more than a feather brushed against my arm. I never know when it's over. I relax in her chair with no intention of leaving. She is a blood-drawing goddess. These are the good days.

Day eleven is a bad day. Depending upon my timing I either get the goddess or the student. The student looks at me with her eyes a little too wide with fear. She is the one stabbing me with a needle, yet she looks more scared than I do. I'm not scared. I'm irritated.

It's a pain in the ass to try to live up to my convictions. I believe in education. Everyone should have opportunities to learn. But do I have to prove this with my skin and blood as she slowly sticks it in, misses, pulls out, gasps, apologizes, tries again, oh man? There must be someone else she can practise on. I bite my lip rather than shouting, "Owww!" because everyone in the waiting room would hear me.

Like the bleached blonde who came in last week, and yelled out, "Oh God, I can't take this anymore! I'm leaving," and began to

sob behind the little white curtain. It was unnerving. None of us in the waiting room could blame her. We could all see that she fell victim to the student blood-drawer, and probably to one too many days of cycle monitoring. There's a reason they tell butchers not to kill animals in front of other animals.

INSEMINATION TAKE TWO

Date: October 22, 2007
Sperm count: 1.25 million
Motility: 71%
Follicle size: 1.7
Estrogen: 723
LH: 27

Waiting #2

Today I pick up my mail in the meeting room at work. I am alone and so I squeeze my breast and pray that the tenderness means that I am finally pregnant. I've read that sore breasts is a common sign of pregnancy, and so I squeeze again. The problem is that, pregnant or not, when I squeeze I feel pain. And the more I squeeze, the more sore they get. I squeeze and squeeze and smile at the pain, but then Sheila walks in and I drop my hands down fast and slide them into my mailbox.

Shit. There's no way she didn't notice that. Sheila is a proper woman, and a proper woman would not remark upon finding her colleague secretly squeezing her breasts alone in the meeting room. *Thank God.* I smile at her and say, "Hi." She smiles at me and says, "Hi," and I'm on my way.

Date: November 6, 2007
Pregnancy Test: Negative (-)

Drugs

After trial number two, and failure number two, the doctor schedules a meeting with me. I wait with Hilary on the blond couches, looking out across the Toronto skyline. I'm trying to read a story about Angelina Jolie acquiring yet another baby, but I'm too distracted. My foot bounces quickly. I push my hand through my hair.

"What do you think she wants?" I'm worried that I'm in some kind of trouble. Even though I'm the client, a client with a PhD no less, I still get intimidated by doctors.

Dr. Meredith walks into the waiting room and calls my name. She greets me with her big, warm smile and I forget my fears for the moment. But when we arrive in her office, the smile is still frozen into her cheeks. "We may want to consider additional treatment."

"Yeah, sure, okay." I'm open to more ideas.

Hilary kicks my foot under the table. When I look over at her, she gives the very slightest shake of her head. I don't understand what's going on. She translates. "What exactly are you recommending that she try?"

"There are several medications that increase follicle production," she continues.

Hilary sits up, her mouth is already half open, ready to counter the doctor's suggestion before she has finished her sentence. "But she's barely begun to try."

The doctor nods, *yes, that's true,* "But our clients want to have the best chance possible each time we inseminate."

"Didn't you say with every try, I've only got a twenty percent chance?" I'm sticking to the numbers. Numbers I understand. And my numbers haven't yet added up to failure.

"Yes, but we find that fertility treatment can be very stressful," she looks directly at Hilary but refers to me, "and we don't know how long she'll last with the regimen of blood testing, ultrasounds, and inseminations."

I look down at the floor. I want to bend all the way over and slide my hand across the cool, polished concrete. I don't want to be inside this room while they discuss me. If I look up, I may tear up, and that would be embarrassing. I don't want Dr. Meredith to see me cry. She barely knows me.

"There is another issue as well," she continues, "The sperm count of the second trial was low. Only one and a quarter million." She shakes her head, "It could mean that their supply of his sperm is not the best quality. You may want to follow up with the sperm bank. They usually guarantee their product."

Do you mean to tell me that I have tried six times (four at home) with mediocre sperm? Six times. Almost a year of work. Over $3000. Six times.

"Thanks for the info, Doctor Meredith," I say, with my eyes still down on the floor, "I'll think about what you've said." I stand up and push my chair back, "See you next month." My ears are hot. I head out of the room, down the hallway, out the glass doors, and over to the elevator. Hilary gathers her stuff as fast as she can and catches up to me in front of the elevators.

INSEMINATION TAKE THREE

Date: November 19, 2007
Sperm count: 3.5 million
Motility: 89%
Follicle size: 1.86
Estrogen: 791
LH: 68

Waiting #3

Waiting. Waiting. Waiting. Can I fill up the day with sixteen separate tasks so that I don't think about waiting? Teaching, grading, meeting, walking, eating, gossiping, flirting, farting, joking, reading, riding, writing, running, sweating, drinking, breathing. Keep breathing. It seemed like a good insemination. The technician conducted an ultrasound on me as the doctor slipped the sperm inside. The doctor said she watched the little bright cloud of sperm swimming in the right direction. Sometimes they don't swim the right way, like a school of fish, abruptly changing direction for no apparent reason. The doctor watches the fish swim away across the computer screen, a failed insemination, $1000 down the drain, for no apparent reason. I wonder what the doctor says to the woman in that case, with her legs up in the air harnessed to the stirrups. She told me, with great confidence, that the sperm swam the right way. But would she have said that if it wasn't true? Does she simply stand there quietly if the perfectly planned procedure dissolves before her eyes?

Waiting is second-guessing every detail. I wouldn't know if she was lying to me. She said it was a good insemination. I don't know her or the profession well enough to understand when you need to be lied to. Perhaps I have a better chance at getting pregnant if I believe the sperm swam the right way. They've probably done research on that. Placebo pregnancies. In that case, I hope she did lie to me.

But the numbers were good as well. 3.5 x 10 million sperm. 89% motility. They're excellent numbers. My egg at 1.86 cm, just on the verge of releasing. Those are great numbers. Add them all up and I've got an excellent chance at getting pregnant. None of those numbers were weak. Those are numbers that make the doctor smile when she talks to me. If I have all the right numbers, I should have a better chance at getting pregnant.

But all of the right numbers together don't mean I will get pregnant. It takes something else. Something magical. Something bigger than numbers. I don't know how to get it. All I've got are numbers running through my head. When I'm waiting, I count the numbers. I've always had an excellent brain for numbers. They stay perfectly clear in my mind, the curves, the sounds, the patterns, the relationships of the numbers. I can remember them for a lifetime. When I'm waiting, I trace over each one and remember its significance to the project. I especially remember the weak ones. They trouble me when I walk down the street, and I wish I could change them, make them stronger, and more useful. But this time, this waiting period, there are no weak ones.

The only thing that saves me is that I know the date I will find out. They give me the date of the pregnancy blood test before I leave the insemination. It is the most solid number I have. I can depend on it.

Date: December 3, 2007
Pregnancy Test: Negative (-)

My Tears Are My Own

Insemination day! Hurray! The receptionist and I gossip about Barack Obama (I'm reading *Dreams from My Father*). The blood test doesn't bother me. Irena conducts the ultrasound with such finesse I barely notice. And I spend the rest of the morning sipping a latte at a cafe. I mark papers with my feet up on the chair. The students seem to understand the theory this year, and maybe they'll still remember it when they start their own teaching.

At exactly 11:00 a.m. I return home and drink the required one quart of water so that my bladder will be full. At 11:30 I hop on the streetcar. Hilary can't come today because she needs to watch the kids. It's pretty impossible to get a babysitter on four hours

notice. I think the kids are old enough to get through two hours on their own, but I'm not their mother. Anyway, it's okay. I'm in a good mood, and Dr. Meredith will take care of me.

I sit on the blond couches clutching my book, haphazardly reading it. I go back and forth in my daydreaming between Obama and the capsule of sperm that I will shortly encounter, and it's kind of weird, but then again he's kind of cute. Why not think about his pretty face during the insemination? I hear a noise from the counter and lift my head up quick to see if Dr. Meredith has come to get me. There's no one there but a nurse in her blue scrubs holding a clipboard. I put my head back down and open my book.

"Karleen?" the nurse in the blue scrubs asks.

I look up at her, then around the empty room, then up at her again. It's definitely gotta be me. Why is she announcing my name? I don't know her. She's not Dr. Meredith. She tells me her name is Lydia and then walks me to a back office. She requests that I remove my clothing, and tells me that Dr. Engelstrom will be in shortly to see me. I look up at her, stunned. She smiles. "Don't worry, I'll leave so that it doesn't feel like a striptease." With that, she marches off and closes the door behind her. Who is Dr. Engelstrom and what does she want with me? Why is Lydia talking about strip shows? What's going on?

Lydia is back at the door asking if I'm ready. "Yeah," I answer, since my clothes are off, but I don't feel ready. She re-enters and asks that I lie down. She rolls the condom over the probe and lubes it up. She inserts the probe quickly and carefully. I decide that she's good at it. She's not Irena, but she knows what she's doing. She clicks away on the computer, capturing images of my follicles. She turns to me and remarks with great enthusiasm that I have beautiful ovaries, "very photogenic."

I blush. They're not really supposed to say anything about what they see. Only the doctors are allowed to speak. Imagine looking

at photos all day long, learning what shapes and dimensions lead to babies, but never being allowed to share your observations. It doesn't seem right. I like it when they defy the rules and say something. Sometimes I try to nudge them into it; sometimes they'll take me up on it, sometimes they won't. But this Lydia, she's got nerve and offers me compliments. Even though I'm butch, it makes me happy all of a sudden to know I have pretty womanly parts inside me. They're hidden secrets underneath my boyish body that only Lydia and I know about.

Dr. Engelstrom is a thin, short woman with dark brown hair and pale blue eyes. She greets me with my first name and a big, warm smile, even though she doesn't look like the big, warm smile type. I think they taught her in fertility clinic school that it was important to smile at clients before you inseminate them. But it doesn't suit her. She should bring me her genuine face, even if it's serious, or frowning, I would feel more at ease.

She knows my name from my chart, but she doesn't know me. It has always unnerved me when people who don't know me use my name. I'm not going along with it. Just because she acts as if she knows me, doesn't mean I need to reciprocate. I do have some feeble ounce of control left.

She's looking over at the photos of my beautiful ovaries, and I'd like her to knock it off. I blurt out, "Where's Dr. Meredith?"

She looks up, startled for a moment, then regains her smile, and informs me that this is Dr. Meredith's day off. She explains that each Wednesday she covers all of Dr. Meredith's patients. She always covers Wednesdays; it says so right on the handouts they gave me the first day. Have I read the information sheets? No. Not only am I vulnerable to a stranger today, I'm also apparently illiterate, or at least lazy.

She stares down at the chart. I watch her counting numbers. Sperm numbers, egg numbers, hormone numbers. Adding up my

odds, frowning. "Everything looks good. You should get pregnant." She shakes her head. "If you don't, it's probably the sperm."

She asks me to open my legs, and she pulls out the plastic syringe with the thin long tube at the end. "If you still don't get pregnant, than I'd advise an IVF (in vitro fertilization)."

I still can't open my knees for her, my thighs are shaking. "How much does that cost?"

"Nine thousand dollars. We fertilize multiple eggs and place them back inside you, two at each try." She convinces me to open my legs and pushes the speculum inside.

Nine thousand dollars. It's a better guarantee. If I do enough of these procedures, it'll cost that much anyway. Can I get my hands on that much money? Where can I get it from? How much intervention am I willing to submit to? The speculum hurts.

When it clicks into place, a tear rolls down my face, then another, then another. I don't want Dr. Engelstrom to see me cry. I don't want Dr. Engelstrom to see me at all. There's nothing actually bad about her, but I don't know anything about her. Why didn't Dr. Meredith tell me? She said so confidently only yesterday that she'd see me today. Or maybe she said, *"We'll see you."* The royal "we," not the specific her. I want to stop crying but the not knowing part shocked me, and now I can't break out of it. Why don't they tell you these things? Like last month. Why didn't they tell me that the progesterone they gave me would prevent me from having a period? I was walking around all proud, knowing I was pregnant because my period was past due. I wasn't pregnant at all. I was drugged. The blood was trapped inside.

I cry some more. I focus on the silver wastebasket in the corner. I don't make a sound. I let the tears splash on the floor and pray that neither Lydia nor Engelstrom are looking at me. They don't have any reason to look at me. Lydia has her photos, and Engelstrom has her follicles. My tears are my own.

INSEMINATION TAKE FOUR

Date: January 14, 2008
Sperm count: 6 million
Motility: 71%
Follicle size: 1.8
Estrogen: 735
LH: 87

Waiting #4

I'm euphoric. Six million sperm are swimming around inside me and I'm euphoric. I do better when I feel I have some control, and this time I did. I informed the clinic that they now have a decent understanding of how my body works, and that I do not wish to have so many days of cycle monitoring, twice at the most. Cutting down on those mornings of blood and probes has been a huge relief. I also asked Dr. Meredith to let me know ahead of time if she wasn't going to be the doctor who inseminates me. Of course, everyone needs a day off, I understand, but if I know ahead of time, I can prepare myself. I spoke. I acted. I imagined myself to hold some role in the medical procedures conducted upon my body. It's only taken me a year to get some balls.

The capsule had six million sperm in it and I think if I get pregnant I'm gonna call my baby the six million dollar man, whether it's a boy or a girl. I fear the collapse in myself if I once more find out that I'm not pregnant. But I'm not going to think about that right now. I'm enjoying myself too much, spending the afternoon up in my office, reading my books, and napping on the guest bed. I won't worry about the possible sadness. I am happy with my big, round tummy and my rested body.

For the first time in my life I want to take care of myself, knowing that I may be taking care of another being as well. I don't

want to drink coffee or alcohol. I don't want my body speeding up and slowing down into a groggy state. I want to eat brown rice and vegetables. I'll eat yogurt for calcium and lean red meat for iron. No soda pop, just water and juice. I'll jog in the mornings and stretch before I go to bed. I want my body strong and calm. Today I love my life.

<div align="center">

Date: January 28, 2008
Pregnancy Test: Negative (-)

</div>

Privilege

Insemination day once more. This time Hilary moves her schedule around and comes with me. My fear of her seeing me in such a vulnerable position dissolves once she's beside me. I was completely wrong about not wanting her here. I was being a butch macho idiot. It's too risky to do it without her. I don't want to take the chance that I'll have a doctor other than my Dr. Meredith because it's her day off. I don't want to undergo another procedure where I cry because strangers are touching me and I'm alone. It's much better to have someone beside me whom I trust.

I am in the dimly lit room with the glowing computers, my legs up in the air. Dr. Meredith works between my legs. Irena smooths cool gel onto my belly. Hilary squeezes my toes. The electrical cloud of sperm swims across the screen. I think of how well I'm cared for. Up at the top of this Toronto skyscraper, I have access to luxury while so many people around the world lack basic health care. It's not right.

INSEMINATION TAKE FIVE

Date: February 11, 2008
Sperm count: 1.8 million

Motility: 74%
Follicle size: 2.1
Estrogen: 643
LH: 26

Waiting #5

I fucking hate waiting. It's an assault on the imagination. I don't know how to hold multiple and dramatically different futures in my mind. I get a sick feeling in my stomach. Nausea. Torture.

When they call, you can tell with the first word out of their mouths. They sound pathetic, or rather they sound like they're sorry for you in your soon-to-be-pathetic state, when you know you're not pregnant and you're sitting on the toilet crying as the blood flows out between your legs. I'm not saying I've got a better idea for how they should sound. There's actually no good way to sound under these circumstances. There's no way at all. Another month, another $1000, another lifeless egg.

Date: February 26, 2008
Pregnancy Test: Negative (-)

Pussies

Irena has stood me up again and left me with a stranger ultrasound technician. I hate when strangers poke at me.

When I first came out, I used to have a "type." I'd fall for dark-haired femmes with big, dark eyes, who had just enough of a butch edge to them that I knew they could jump me and make love to me if necessary. Later, after kissing a few more girls, my mind was opened. I could fall for just about any woman's looks—any hair colour, eye colour, face, body type—if I felt a connection, a shared sense of humour or politics or passion. Or if they are excellent

at performing some type of skill in front of me, anything really; it could be teaching, cooking, swimming, painting, fucking, doesn't matter, they just gotta be good at something (Note: I was influenced by the film *The Tao of Steve*). I watch them and feel a blush spread across my cheeks as I proceed to avert my eyes with a small, shy crush.

I'm willing to be just as open-minded in accepting new ultrasound technicians. They don't need to be pretty in any conventional way, but I do want a moment of connection. Perhaps some eye contact, a warm word or two, maybe an acknowledgement if I joke about something, the slightest sign of a smile. Today I get none of it. The tall, pointy, brown-haired, blue-eyed woman holds a clipboard and directs me into her office. She requests that I disrobe but when she returns, I am informed that we are moving to another room. She has me scoot across the hallway with my ass hanging out from under my shirt, praying nobody will come around the corner at that precise moment.

The worst part, however, is the procedure itself. If she was smooth and confident with the plastic wand, then I'd have some respect for her, and she may even elicit a blush, but she's not. She approaches my pussy like she's never seen one before. She rubs hesitantly in the general area, but fumbles like a schoolboy at finding the actual hole. It's like she's scared of it. I want to shout out that there's nothing frightening about pussies! Don't be such a straight girl! I want to grab the wand from her and push it inside me. I want to show her how to enter a woman. They should have lesbian consultants for their training sessions.

Once she actually locates it, she snags the hair and skids painfully along one side. *Ouch. Fuck.* Now I'm not so much annoyed as I am angry. I don't want this ugly woman between my legs, hurting me. I start to have violent fantasies where I'm punching her. The hospital is raping me on days three, eight, ten, twelve with these strangers and their hard, white probe. I'm in

a relationship with a technological apparatus, a cold and sterile machine.

I close my eyes and think about Irena and Dr. Meredith with their tender words, their expert hands. I thank God for them. They save me.

INSEMINATION TAKE SIX

Date: March 7, 2008
Sperm count: 2.5 million
Motility: 77%
Follicle size: 0 (already fallen)
Estrogen: 478
LH: 32

Waiting #6

I've trained myself to put the phone on silent mode. No ringer. No vibration. I don't want to be interrupted. I don't want to be at the market, on the street, or in class when I find out. I don't want my nap cut short by bad news. I want to choose when I hear it. I want the power to push the buttons to direct the answering service to play her words: "Ms. Pendleton, the results are negative this month."

I decide where I'll be when I hear the words. I decide how much of the message I'll listen to before I cut it off. I decide where I'll cry:

In my bed, under my down comforter at dusk, the room darkening over me.

In the TV room with my running clothes on, ready to race across the streets of the west side.

In our back garden where I can sit with the peonies over-ripened, perfumed, falling to pieces.

Date: March 21, 2008
Pregnancy Test: Negative (-)

A Prayer

I don't know what it takes to make a baby. I don't know how to prepare myself for an insemination. The casual approach, where I just hang out (take a nap, write emails, listen to the radio, read a book, gossip with my neighbour—in short, any activity where I am not directly thinking about getting pregnant) hasn't been working. The pervy approach, where I have sex before the insemination or think about every hot woman I desire, while certainly entertaining, hasn't done the trick either.

I'm not a religious person, but I do wear the *Virgen de Guadalupe* on a gold medallion around my neck. She is the goddess of Mexicans and Chicano/as everywhere, and I trust her to protect me. I haven't prayed since I was a teenager, but this could be one of those situations. It's pretty specific (I want the miracle of life), and I think religious figures are in that line of business.

Today before I go see Dr. Meredith, I take a long, hot bath in the pristine white bathroom that Hilary designed. I breathe slowly, I rub soap along my skin; I lay my head back, close my eyes, and think about how sweet a baby's skin smells. Tears roll down my cheeks.

I pull myself out of the bath and kneel on the thick bathmat. I clasp my hands together. I don't know what to say exactly in a prayer. I'm not even sure how to address her.

"*Querida Guadalupe*. It's Karleen. In Toronto. *Por favor*. Please can you help me? I need to make a baby. I need a baby so badly. Ever since my mom died, I've been so lonely. It feels like a piece of my body is missing. Like I'm walking around without my heart. I can't be alone anymore. I can survive, but I don't want to live like

this. I want more. I want my own child. My own flesh. I'll try so hard to be a good mother. I'll give her my love, good food, joking, my attention, I'll breastfeed, I'll pay for her university, anything I can think of. Please. Please help me. *Gracias*. Amen."

I grab hold of the medallion, and hold her in my fist. I kiss my hand and let go.

Therapist's Office

My body feels like a heavy, crumpled mass of crap. I want to sink down and cry all over her leather couch.

"Do you think I'll ever get pregnant?"

I ask one of my most stupid questions because I'm feeling desperate. What possible answer can any mortal offer me? The poor therapist.

"This must be really hard for you," she says to me. "You're used to working hard for what you want and getting it."

I nod. "Yes, I suppose that's true."

She looks straight into my eyes. She can't soothe what can't be fixed. All she can offer is honesty, and point to humility. "Can you accept that this time, you have no control over what happens?"

. . .

Lifesaver

I want to have a baby to save my life. There, I said it. You can't get more selfish than that. I'm lonely and I lack meaning. My work isn't cutting it anymore. I used to get a high from teaching a class well, or writing something clever, or publishing. And don't get me wrong, I still do, but it fades quickly (within the hour). And I'm still left with long nights trying to figure out what my point is. I sit downstairs at the kitchen table with my diary, searching.

INSEMINATION TAKE SEVEN

Date: April 6, 2008
Sperm count: 2.75 million
Motility: 74%
Follicle size: 1.9
Estrogen: 726
LH: 52

Waiting #7

I am trying not to get my hopes up again. I feel no different and so I expect them to tell me there is no difference in my body. But the numbers were good, and I fought like crazy to get the sperm. My credit card hadn't gone through so they cancelled the order. Only nobody called to tell me. Insemination day was to fall on the weekend and unless I could get an express shipment Friday afternoon, I would have to give up the month.

I whined into the phone receiver. I begged the woman at the sperm bank for help. I called Hilary to borrow $800. I filled out a form for a new credit card. I wanted to barf. I kept thinking about the mornings I spent being pricked for blood and fucked by their machines, all for what? For nothing? There was a moment Friday afternoon when I just felt like dying, but then everything changed. Everything worked out. The sperm arrived. The procedure took place successfully. If I fight so hard, do I have a better chance at getting pregnant? Might a bunch of these struggling moments amount to something? Can they add up to a baby?

Date: April 18, 2008
Pregnancy Test: Negative (-)

Therapy homework

1) Hold babies. This helps you get pregnant.

Note: This task is difficult for me. Butches are like men. We don't really hold babies. Nobody offers them to us, and it's too presumptuous to grab one. It would be like taking the only chair when you're in a room full of femmes who might appreciate that chair. It would be ungentlemanly. It wouldn't feel right. But it makes me sad. I want to hold babies.

Will I go through so many of these procedures for so many years that I'll stop feeling anything altogether?

INSEMINATION TAKE EIGHT

Date: May 3, 2008
Sperm count: 10.5 million
Motility: 86%
Follicle size: 2.1
Estrogen: 877
LH: 23

Waiting #8

The week after I get the call is miserable. Everyone around me begins to annoy me. Someone in the family coughs, or bites their nails, or talks loudly, or snores, or laughs. Their living is annoying. Their joy is ludicrous.

I accidentally drop the newspaper I'm carrying, I hurt my ankle when I go running, I put too much salt in the rice, the defrosted meat for dinner has gone bad. There's not enough sun on the horizon. The city has too many grey, rainy days. All of the planning, sleep deprivation, finances, excitement I've dedicated to the try have yielded nothing. Nothing is growing inside. Nothing is in my hands. There's nothing to look forward to.

My temper is short. I fight to edit snippy remarks at the kids and at Hilary. I become an asshole to live with.

Taking stock. It's getting fairly depressing. I climb off my bed and lie on the cool, wooden floor. No pillows or blankets. I stare at the ceiling. I follow the lines of the paint, sagging and peeling. The white paint has yellowed where the ceiling leaked years ago.

<div align="center">

Date: May 16, 2008
Pregnancy Test: Negative (-)

</div>

Rules

Whenever anyone makes a rule, there's a part of me that wants to know what will happen if I break it. Not big rules. Not rules where somebody would get hurt if I broke them. Tedious rules. Rules that structure orderly conduct.

"You must call us on day one," says the fertility clinic, "so that we can sign you up for another round of cycle monitoring starting on day three." You know what? Day one sucks. Day one officially registers that there is yet another month without a pregnancy. Day one is full of dark blood. Day one is a day of mourning. I don't want to follow rules on day one. Even though it gives them the time to write up a requisition form and have it ready in the right hands when I walk in. What will they do to me?

I stroll in on day three for blood and ultrasound work, and face the fire.

Jenny the nurse instructs me to follow her to a back office. She walks swiftly, her hips shift back and forth in her blue scrubs. I know what this is. This is me getting in trouble. I know a principal's office when I see one. She lets me in the door, and then closes it behind us. She informs me that I did not call on day one as I was told to do. She informs me that they cannot accommodate

me today and, therefore, will unfortunately not be able to provide cycle monitoring or insemination this month.

"Sure, okay," I say, "That's fine with me," and walk back out. I will show no weakness with Jenny the nurse. She has pulled me aside to punish me, but I won't flinch. The truth is that I don't care if I can't do it this month. My heart's not really in it. I don't think I can even pay for it this month. The costs are killing me.

It's like a gambling addiction. It's like drugs. If I just try one more time. If I just get a little more. A few more drops of precious sperm will do the trick. I'll shoot a killer game of craps. I'll win the lottery. It's only another thousand dollars worth of debt. I can always apply for another credit card. As it is, I've already maxed out two. How much work do I have to do to earn a thousand dollars? How many years will it take me to pay off the debt?

I keep that debt tucked far away in the back of my brain. Occasionally it surfaces like a fire growing in the corner of the living room, and I panic and run out of the house. If I close the door I don't have to see it, and nobody else will notice it for a while. Holy shit. You gotta blow your money on something, and I might as well blow mine on this. But how much are we talking? How long will this go on? I gotta face that it ain't working.

I'm desperate. I look at my girlfriend and all of her nice things, her home, her children, her shopping. I'm jealous. I want her money to help me. But I can't ask for it, and she doesn't have enough for me anyway. And what will I have to show for it? An investment in probably nothing. No sweet babe to cuddle in my arms.

But if I win. If the child comes to life, then I have everything I need in the world.

I am so irritated, I walk all the way up Bay Street and across College to get home. I'm hoping the trek will tire out my body

and the anger will evaporate. I don't want to bring it home with me. Hilary's not too pleased with my moods lately. The high from the insemination only lasts a couple days. The waiting makes me anxious, impatient, and far away. The negative results knock me on my ass. I hide out in the attic and work so that I won't think. I snap at her when she isn't attentive enough.

She isn't attentive enough for me and my fertility-world drama. Nobody could be. She seems busy all the time. She's either at work, at a meeting for one of her volunteer organizations, or planning some new renovation on the house. Can't she see how sad I am? Can't she make it work? Can't she get me the baby? She just carries on like I'm not a pathetic heap.

She doesn't see me when I walk in. She's stripping paint off the hallway trim. She doesn't notice the look on my face. She doesn't think to ask about Jenny the nurse. She didn't go with me, so she wouldn't know.

"Do you even care how it went today?" I launch the accusation. Because I'm an idiot.

And then she's off. She's ready for the fight. She's had enough of my foul temper. Do I know how stressed out she is?! Do I know that she has two hearings this week?! Do I know that she needs to strip the paint because it has lead in it?! If I wanted her with me why didn't I tell her…?!

And I'm sorry I said anything, as much because it wasn't fair as that I don't want to face the hefty counterattack. I get away from her. I head upstairs and cry. I grab my hair in my fists and squeeze until my scalp aches. I kick the bed. *Fuck. Fuck. Fuck.* What am I going to do?

I don't want to fight with Hilary. If I fight her then who is left on my side? Who will come with me for the next scary insemination? Who will stroke my hair when they inject a million sperm inside of me?

I pace the room for ten minutes, wiping the tears from my eyes. I take another ten in the bathroom, slowing down my breathing and scooping cold water over my face. Then I head back downstairs to make peace.

9. Vancouver
(May 30, 2008)

I plan from the sky. The sun shines through my window, and the clouds lie thousands of feet beneath me. They are soft, long, gleaming, spread out before the plane. I sip on a rye and ginger. From up here in the heavens, I can do anything. I am not a shaky dyke laid out on a doctor's bench, waiting for an insemination. I'm not a professor heading off to yet another academic conference. I'm the star of a movie, calculating my next move. I will get to the hotel early, take a nap, shop for supplies, take a bath, put on my best clothes, and find a bar. I will ask the cab driver from the airport where straight people go out to dance. I will find a local paper and see what venues are advertising live music. I will find a man tonight to get me pregnant.

Scattered condo towers surround me as we drive through the streets of Vancouver into English Bay. When I ask the cab driver where there's a good place to dance, he hesitates. Do I want to dance with women or men? I like cab drivers. They're practical. The guy's only known me for a few minutes and he's basically asking me my sexuality. He is an expert at picking up people and taking them to the right place. He wants to help me get to the right place. "Men," I answer.

He continues on without hesitation. He suggests the clubs down on Granville Street.

"Wait," I say, "just in case, where are the women's bars located?" I don't need them tonight (day twelve), but I might want to go out later in the week.

There's a Shoppers Drug Mart a half block away from the hotel. I search the aisles for products to help me get laid. Makeup is out of the question. I have no idea how to apply it, and I won't look like myself. Hilary has a theory that what is most important is that you stay true to your look; a wide variety of looks are appealing, what

turns people off is a falseness or discomfort in your own skin. On that basis, pantyhose won't work either. Perfume seems wrong; I've got my cologne back at the hotel room. Razors? Yes, razors might help. I've shaved my legs before, and it wasn't so bad. Some male athletes shave their legs: swimmers and bicyclists. That would be okay. The girlfriends I've had have always complimented my legs. Besides, I don't want some guy ready to make love to me to stop at the last moment when he rubs his hands down my shins.

Half the aisle is full of razors: pink, purple, silver, blue, two-packs, three-packs, ten blades, four double-blades, electric. I stand trapped by the choices I am forced to endure. It reminds me of the first time I bought shampoo at the store, sitting on the floor for forty-five minutes trying desperately to understand what the labels were asking of me. But that was before I had a girlfriend who saved me. Shopping can be hard on butches. It is my first solo act of this adventure and I'm already feeling helpless. I choose the heaviest black razor (with a selection of blades in a triangular accoutrement) and Old Spice shaving gel to do the job.

I pick up a plastic syringe in the pharmacy area and then find myself in front of fifty different brands of condoms. Do I need condoms? What if he insists upon using a condom? Although I can hardly imagine a man insisting upon using a condom (from what I've heard). Would they risk pregnancy or disease for the sheer pleasure of one night? Surely not all men are this reckless. Still, what if I manage to convince one to come home with me, and he happens to be the sensible one. Is there a way to salvage the sperm? Could I keep an eye open after he's done, to see where he throws the condom? Could I make some excuse about needing to go to the bathroom and somehow grab it on the way? In the bathroom I'll have my plastic syringe. I'll quickly suck in the sperm and deliver it to the proper place. But how do I retrieve the condom without him noticing? Hop off the bed and duck on my way out? I'll need a distraction. I know, I'll tell him I'm shy and ask him not

to look at me naked, running off to the bathroom. That would be true. Is it realistic to be shy after I've just let him fuck me? I mean, would he buy it? I think guys believe that women as a whole are neurotic about their bodies, so maybe he wouldn't give it a second thought. I would have to act fast though. Sperm can live for only a few minutes outside our bodies; some people think an hour, but I don't want to push it. Would it be rude to jump up so quickly after sex? Would he be offended? Do guys need that mushy, lovey talking after a fuck, or are we both free to go?

And, finally, is it unethical to take sperm from a man through a stolen condom? At the very least, it seems a bit unfair, and kind of gross. If he chooses to have sex without a condom, I think it's his own damn fault; he knows what the possibilities are. But a stolen condom, that's something else entirely. On the one hand, I still feel that if I've put out, I've earned the sperm. On the other hand, what kind of relationship have I started for the baby and father? Have I reached such desperate acts yet? I walk out of the condom aisle. If I'm faced with the dilemma, it'll have to be because he remembered to bring a condom, not me.

Back at the hotel I take a long bath. I let my whole body drop under the hot water. The sound compresses; I feel comforted by the silent pressure against me. How long can I hold myself here? I am perfectly calm and soft and safe. If I stay here, soaking in the tub, I won't have to go to the bar and risk injury to my body, or humiliation when I can't find anyone to sleep with. I won't have to be an adventurer. I don't have to make a baby.

I touch my skin and take inventory: big floating breasts, a round tummy that rolls like dough, a vague outline of hips, slim runners legs. The only time I ever feel like a girl is when I'm naked. It seems probable that a boy would want me. If I look in the mirror the sensation ends abruptly with my reflection: a smooth boyish face and a short haircut tapered on the back and sides. It doesn't help that the hotel has wall-length mirrors the size of

the bathroom, revealing parts of my body I hadn't remembered. I sigh and cover my eyes with my hands. How do I transform a butch body? Why do I feel the need to transform it? Are guys only attracted to femininity?

When I was a teenager my *abuelita* advised me that I'd be able to get a man if I shaved my legs. I want to convince myself that one small part of me can stand in for the whole. Metonymy. If my legs are shaved smooth, shapely, female, I become an appealing figure for the men at the bar. In reality I appear as butch as ever, but it doesn't feel that way. And feeling is what I've got to hold onto. It will give me the confidence to catch the cab, pay the cover charge, walk into the bar, choose a stool, order a beer, and stare down the boys. My legs can get me through the night.

I pull the blade from the plastic package, raise my leg, smear foam across it, and glide the razor across my skin. As I work my way across my shins, carefully, bloodlessly, I think of Terri, a butch I knew. She was straight, but very masculine, the outdoors type. She looked great in a polar fleece jacket and canvas pants. She had broad, muscular shoulders, beautifully sculpted cheekbones, and blonde, wavy hair. She could have had any woman she wanted, except she didn't want one, or at least she said she didn't. I wasn't sure whom she wanted; she was quiet and removed on matters of desire.

One day as we sat together studying at a café, out of the blue she started muttering, "Clean your ears." She raised her voice, "Clean your ears!"

I looked at her, startled, waiting for an explanation.

"Clean your ears!" she repeated. "That's what my mom used to say. Clean your ears and you'll look like a nice young lady." She didn't look up from her book (*Gender Trouble* by Judith Butler), but she raised her hands and touched her ears. "I poked and picked my ears until they were red and as clean as they could ever be." She

lowered her hands and lifted her eyes, "But I never looked like a nice young lady."

When I was six, I got earrings so people would stop asking whether I was a boy or a girl. When I was eleven, I thought all I needed were bright-coloured shirts to make me look more feminine. At sixteen, I hoped a pink sweater would do the trick. When I came out a couple years later, I stopped trying to look like a girl and relished instead a much more successful career as a boy in love with girls. For nearly twenty years I haven't given a second thought to making myself more feminine, but faced with the challenge of acquiring sperm, I'm right back where I started. My instinct is to find the one new accessory for the masquerade. I appear to have learned nothing from a history of futile attempts. Perhaps the strategy is more for me than anyone else.

Hilary has a theory about relationships. She believes we are bound by a point system. The system applies to encounters as short as a one-night stand or as long as a golden anniversary. Each individual brings to the table a complicated combination of characteristics that are tallied by the other person (consciously or not) to determine whether they are suitable for the relationship. There are numerous potential traits that may be considered or cashed in: age, looks, intelligence, money, culture, charm, humour, type of work, general or unexpected skills, artistic talent, etc. Some of the characteristics are valued according to North American social hierarchies, some are particular to individual taste.

For example, there is the obvious exchange: a wealthy older man picks up a beautiful young woman. He brings money, she brings youth and looks. Or the less obvious: a lesbian couple where one woman is an outstanding lover but most people only see her terrible temper, while the other smiles all the time but isn't very smart. They trade in their assets and limitations and they balance each other out. In the second case the points are hidden or unexpected, but they still drive their choices. We are not searching for the person

who possesses the most points, rather we are looking for someone whose point level is closest to our own. We are interested in similar quantities of points but not necessarily similar kinds of points, as evidenced in the examples above. Substantial disparity between points can lead to an awkward evening, an embarrassing rejection, a stalker, a nervous breakdown, unnecessary disaster. It may be a callous way to view love affairs, but not superficial. In any case, the point system provides me with an approach for navigating a bar.

The phone rings and bursts apart the silence of the hotel room. I leap from the tub and run to the phone. My friends, a very respectable lesbian couple, invite me to dinner. I am dripping, half-shaven, and unprepared, but they are giving me an hour and a half before meeting up. I hesitate, then agree. I decide it's best to have a good time, eat well, then go later in the evening to a bar. I don't want to get to a bar too early. It's depressing to get to bars too early. The cheap vinyl seats and dingy walls, which can be magical when the room is full of sweaty bodies, look tacky and smell sour when they're empty.

I put on the most feminine-looking underwear I own: half-sized boxers (without the fly) and a black silk bra. Over top I put my tight brown pants, a V-neck black T-shirt, and a dark Italian blazer with silver buttons. I reach for the newspaper (I took it from the lobby when I checked in), and begin investigating potential venues. It's an easy pick; only one bar in the city has a live band tonight (a Thursday night). The Roxy. I highlight the Roxy on the newspaper. I like the sound of the name, a place to begin a passionate night. I could tell my baby that I met her father at the Roxy. And since I'm not local, I've got no other stories of the place to go by. No baggage.

· · ·

We dine beside giant windows overlooking English Bay. I cannot make out the details of the mountains across the water, only the

dark outline as they descend into the ocean. A giant tanker glides by, moving slowly in our direction. My friends have brought me to the Sylvia Hotel, a turn-of-the-century landmark built of brick and terracotta. I am drinking a glass of white wine in Vancouver's oldest cocktail bar. Everything about the place is elegant. I eat a fisherman's salad as my friends share stories of famous authors who used to come here to write and play. I devour the sweet flesh of the scallops alongside the lesbian gossip, and smile at my good fortune. I have good friends, good food, a good life. I could fret about the fact that this should be more than enough, and I must be out of my mind to gamble my life tonight, or at least my pride. Instead, I absorb the lovely evening that only encourages my daring. In another hour, I will jump off the edge of that farthest mountain and pray that the ocean will catch me.

The cab drops me off on the sidewalk in front of the glowing red Roxy marquis. It feels farther away than the three-kilometre drive—from fancy hotel to dance club, from sophisticated lesbians to young, drunk university students.

They scan my driver's licence into a machine at the door. If I get pregnant tonight they'll have a record of the man's identity. Would they release his information to me if I explained my situation? I could call them when I'm eight months pregnant, desperate for his name, and plead my case on the phone. Is there a policy on this sort of thing?

Inside, there is a large room with a stage for the band, a dance floor, and several sections of tables, bar stools, and stand-up drinking. There are thirty people already here at 10:30. The band goes on in a half hour and many more customers follow me in line. It's a busy night for a Thursday, but I am doubtful about finding anyone. The clientele is largely mid-twenties, white, university students. They look like a bunch of frat boys and sorority girls. They look younger even than my B.Ed. students. It goes beyond a question of points, it just feels weird. I'm not attracted to people

so much younger than me. I can't imagine making one of them a father while he's out playing after class. What would I look like to one of these clean-shaven, blond, curly-haired twenty-one-year-old men? He would wonder, *Why is this old dyke trying to pick me up?*

Once the band starts playing, a few more older people fill the room. However, the demographics remain pretty white. The opportunity for a Latino father at this bar is even lower than in the sperm banks. I don't see anyone who looks like a possibility. I would have needed more time and more research to find the Latino bar in Vancouver. It would have been fortunate if one existed, and nearly impossible if it had a dance night on day twelve. Getting pregnant with a Latino father is easier done in pretty much any other country on this side of the world than Canada. Tonight, hours before ovulation, my body hungry, ready to jump, I just want the best man I can find in this bar. Hopefully, my people will forgive me.

An Asian man in his forties sits down ten feet in front of me. He's tall, looks strong, wears a navy blue blazer with jeans. That might work out. He dresses like he has a decent job and he's sipping on a dark beer, not guzzling some crappy $3 special. My first love throughout high school was Korean and I've always looked twice at handsome Asian men ever since.

I watch him watch the band, and decide that he's come to enjoy the music and not to get trashed. The band is fun, passionate top 40s rock. A woman with pink hair and a silver dress sings the first couple numbers: "I Love Rock 'n' Roll" and "One Way or Another." Then a bald man in sunglasses and a shiny green suit trades off with her, singing "Billy Jean" and "Faith." The Asian man is tapping his fingers to the beat.

What line should I approach him with? "Is someone sitting here?" "Do you know this band?" "Can you believe all these twenty-year-olds getting drunk?" Everything sounds vague and boring. "Would you—?" *Oh damn.* Two other men sit down next to my

guy. One looks like a friend and the other a son or something, much younger. A family outing. I can't pick up a guy at a family outing.

I begin a new search that lasts forever. I've nursed my single bottle of beer for the past forty-five minutes and need to face up to the fact that I need more. It feels like I've gone back twenty years to the first gay bars I snuck into as a teenager. I had no idea what the rules were, how to get a woman, how to not piss people off, how to not get thrown out. With the little money I had, I'd buy a cheap bottle of beer, hold it tight in front of me, and nurse it all night. If I didn't wiggle around too much, if the lights were too dim for people to see my hand shaking, I could pass as someone who seemed confident and belonged.

When I turn to check the lineup at the bar, I spot a silver-haired man. He's handsome, tall, with muscular arms and shoulders and casual/nice dress: black shirt, jeans, black leather shoes. What's he doing here? Would he seem too old for the university students? I don't know; he's attractive to me. I probably wouldn't seem too old to him. But am I good-looking enough? *Shit, I don't know.* I look back and then look again. He's watching the band. Maybe he's come just for the music. Maybe he has no interest in picking anyone up.

On the third time I turn and look at him, he smiles back at me. I respond with a grin and slowly face forward once more. The singer from the band is shouting the lyrics out of her small frame. I've got a decision to make. Do I jump off this bar stool and approach him? Do I stay and wait for another guy, or for the end of the night when I can return to the hotel untouched? Do I have the balls to make the first move?

I am frozen to the bar stool and unsure whether my legs would comply even if I commanded them to move. The singer pushes her hand through her hair and holds the mic way up in the air, belting out the song. The crowd in front of me watches her intently, and beyond them the dance floor is packed. There is an intoxicating

quality in music that lures me into life. Whatever mood I possessed before is displaced by the world of the song. This song is hard rock, it is a bold woman in torn fishnets on stage; this song is a bar full of young revellers erupting, ready to grab at their lovers. The guitarist takes over, grinding out the melody layered in minor chords and hypnotic riffs.

What life do I choose to lead from here on out? One with missed opportunities? Chances slipping by? Do I want a life like my *abuelita*'s, reciting her regrets over and over again like prayers before she died? How many years do I fail at the fertility clinic, the insemination process leaving me cold and broke on the examining table? I don't want to give up like that. That's not how my story ends. I slide down off the stool, take a last swig from my beer, and strut over to my silver-haired man.

"Would you like to dance?"

"No thanks, I—" he replies.

I blurt out, "That's cool. No problem," before he can finish his sentence.

I am about to turn around when he stops me. "No, wait, I'll buy you a drink."

Okay, that's something. I breathe again. I order a rum and Coke and climb onto the stool next to his.

I find out he's a lawyer; he finds out I'm a professor. We're both in town for conferences. He's some kind of corporate lawyer, which sounds boring to me but potentially smart. I like his eyes, alert and kind. I like his smile that spreads a rosy flush across his cheeks. He must be in his mid-fifties with his wrinkles flaring out from his eyes.

Hey, it doesn't matter if he's twenty years older than me. This is a smart, good-looking man, same genes no matter what the age. He orders me another rum and Coke as soon as I empty my glass. I want to laugh. Does he think he can get me drunk so I'll be easy? He has no idea how easy I'll be.

He drops the line, "I used to play hockey. I was in the NHL."

Now I think, *This is getting fun.* Not only do I have the opportunity to make a strong, athletic baby, but I could sleep with a former NHL player. Is this on some Canadian checklist somewhere? When in Canada, sleep with a hockey player at least once. I chuckle. It does the trick. It impresses me. This time he asks me for a dance.

We dance together beside a few women who are whispering and giggling. Occasionally they wave to the silver-haired man. He explains that they're here for the conference too. Maybe. If he's telling the truth. No reason to lie. But when you pick someone up at a bar, you can describe your life however you choose. In my case, everything I offer about my life is true, except that I don't exactly volunteer that I'm a lesbian. I feel a little guilty about that, having been out for eighteen years. But that would be confusing. Why then am I interested in him? It can quickly lead to the grand omission of day twelve and pregnancy. If there's anything I've learned in this whole process it's that there's nothing like talk of pregnancy to scare a man away. But I don't want anything else from him—no money, no gifts, no responsibilities—just the precious life inside him. Is that too much? It's the whole world.

I allow my breasts to accidentally brush against his chest. He smiles at me. We've both got the same easy two moves on the dance floor from side to side, a guy's standby step. I look at his face. Up close he reminds me of Hilary, maybe one of her handsome cousins—round nose, full chin, pink cheeks, a bit of Ireland in front of me. *That's fine*, I think. If not Latino, then one of Hilary's people. A baby that looks like it comes from both of us. He excuses himself to go to the bathroom.

I'm not so smooth. It's only my second attempt at a bar, and I make mistakes. While he's in the bathroom, I look down at my hands and am startled to see my wedding band. I pull it off quickly

and shove it in my pocket. *Shit.* Did he notice it? *Stupid.* Of course he noticed it. How could I forget to take off my wedding band? I'm not even married, but I'm here presenting myself to the world that way while attempting to pick up guys. *Great.* And I think straight people take that stuff seriously. *Oh Man.* Hilary gave it to me one afternoon as a sign of our commitment to love one another, but not of our monogamy. Never monogamy. We're both opposed to the constraints of that lifestyle. Too stressful. It's not exactly something I could explain very easily though.

I look around again. He's nowhere, not at the bar, not on the dance floor, not by the band. I grab one hand in the other. I try to rub the indent from the ring off my finger. I raise my finger up five inches from my face and focus on the skin. It's no use, the small section of skin is softer, shinier, paler than the rest of the skin on my finger. *Ugh.* What am I doing with my hand up in the air four inches from my nose? If he doesn't notice the evidence of a wedding band on my skin, he'll surely notice my obsession with the finger. I think I'm drunk. The bar is dark; nobody is going to see the wedding band tan. *Get a grip.*

Okay, where is he? Where did he go? Is he watching me? Has he left? He's left, for sure. He got a sense that something was off. Why would a relatively young dyke show up in a bar and try to pick him up? Would he have any idea what I'm up to? Do guys think we may be out here doing this kind of thing, or are the odds of such an encounter fairly slim. Am I the only one? I can't be the only one. I might be. I give up on my silver-haired man and walk closer to the singer. If he's not here, I need to enjoy the band and ignore his disappearance. *Damn, it stings to lose the guy after all that flirting.*

A tap on my shoulder makes me jump and he's standing behind me, looking at me with a serious expression. He is carrying yet another drink for me. *Oh, thank God he's here.* What's wrong? Why is he frowning at me? "What?" I ask. "What's wrong?"

"So what's the deal?" he wonders, gazing down at my naked finger, "Are you married or what?"

"No," I say truthfully. I'm a terrible liar and it is such a relief to have a question about my sexual status that I can answer with one hundred percent honesty.

He looks right into my eyes as I answer and finds what he needs. "Good. Then let's dance."

This time he is ready. He does not hold back. He is no longer a gentleman. He steals a grab at my breast in the middle of the dance. He goes in for another. I've caught him now, and I'm happy. I can do without the stares of his conference women friends though. I lean over and whisper, "We should go somewhere."

A smile fills his face. He grabs my hand and turns abruptly for the door, the two of us giggling like kids. We're getting away with something bad right in the middle of all these people.

In the cab he stops kissing me briefly to suggest we stop at a store on the way to the hotel to get condoms.

"If you want to," I gamble, " but I'm on the pill."

He doesn't want to.

. . .

"Turn the lights off," I insist before he gets into bed with me. I can do this in the dark. I can do almost anything in the dark. I'm free to fantasize whatever picture I need. I cannot see myself having sex with a man, but I can imagine someone else in this predicament. Sometimes she is a woman who is a wild animal, sometimes she is a tough butch, sometimes a gay man. I switch between these images of myself as he lunges for me.

He is hungry, urgent. He moves quickly. He tosses me around. He tears my clothes off. He squeezes my breasts, bites down on my neck, rubs my thighs. I scream out in pleasure. He pushes his fingers inside me. I suck in a mouthful of air. I'm wet. He's good. He

works me. *Oh God, oh shit, damn, he's really good.* I scream again and he warns me to not be so loud. But his fingers are beating hard inside me, angled just right, shooting heat from the centre of my body out to every limb. So what choice do I have? He caresses my smooth leg with one hand and pounds me with the other. *Oh man. I totally lucked out.*

He pauses, presumably to pull down his pants, giving me a second to take in a deep breath. I am terrified at what he'll do next. Can I take it? Will I be okay? I've only done this once before and that was twenty years ago and it wasn't the best experience. *It's for the baby*, I think to myself, *It's going to be okay.* I squeeze my eyes shut tight and wait, but nothing comes. What's going on? Where is he?

He falls down beside me in bed. He whispers, "Please. Please help me. I'm still soft." He touches my lips with his finger, and gently pushes the tip inside. I understand. I could be repelled at this moment. I'm not much for blow jobs. But there is a pleading in his voice, a helplessness. He wants to continue to do a good job, but he can't get hard. Would I? Yes.

I take his soft body into my mouth. I push him deep inside. I close my lips around him. He is sweet and safe inside. At this moment, I don't care if he ever gets hard. He lies back, defenseless. His body tenses and loosens in rhythm underneath me. I want to thank him for his touch. I stroke him slowly, thoroughly, and he moans and jerks around.

Suddenly he stiffens. He leaps up. He reaches for my knees and pulls them apart. He drives himself inside me. It feels great. It feels like my girlfriend inside me. It feels like a smooth, warm dildo. I imagine her confident above me, pushing, pinning me down. It's fine. It will be okay. So this is sex with men. I always wondered what all the hoopla was about. It's thoroughly enjoyable, but nothing another woman can't do. He moves quicker. He breathes fast and heavy. *All right, come on, guy, please go ahead.*

He doesn't finish the job. He doesn't make it there. He lies down beside me panting, exhausted. I would be exhausted too if I just fucked someone that well. As another top, I know precisely how much energy and focus is necessary for such a brilliant performance. The man is an excellent top. I am impressed with his skill, his intensity, his strength. He's got grace, vulnerability, talent. If he could just provide one last gift.

He starts laughing.

"What?"

"I can't believe I just had sex with a professor," he states proudly.

Now I'm chuckling. Who knew that would be it? I go over my list, my assets, and I had no idea the professor thing would be the key to this affair. Hey, I'm glad it came in handy.

"Have you had sex with a lawyer before?" he asks hopefully.

I think of Hilary in her gorgeous suits she wears for hearings. "Yeah, sorry," I answer.

"With a hockey player?" he tries again.

I flash through dyke ex-lovers in my mind who might have been hockey players. "Maybe," I decide, "but never from the NHL."

He is happy with my response and we get to talking about our lives. He's from Nova Scotia but he lives in Manitoba now. He has land with a meadow and a river, and crops of corn that a nearby farmer harvests. He has children: two daughters and a son; they're in university now. Because of hockey and business, he has travelled to every big city and a few small ones across North America. He loves Baltimore; he hates Chicago. He vacations in Hawaii.

"Which island?"

"Kauai."

My dad worked for an airline when I was a kid, and Kauai was our favourite place on the planet. Maybe we have at least one thing in common. "Have you gone up in the helicopters?"

"Yeah," he answers, surprised. "Over the canyon?"

"Into the volcano."

"Right. It's incredible how green it is inside."

"It's the first volcano, you know. The one that created the whole system of islands." I feel connected to him for an instant. I've never met anyone else who has been there. "Flying right down into the crater where it's lush. The mouth of the earth. It's the most beautiful thing I've ever seen."

He finds my face with his hand and brings his lips down onto mine. He starts again. He doesn't need help this time. He caresses my body and moves inside. I feel the joy in his rhythm rise and extend. But when he reaches climax, he abruptly pulls out, and explodes onto the bed.

"No," I plead, "please don't pull out."

He seems to have his own strategy for the night though. Maybe it's his technique for avoiding paternity. He tricks me. He leans down and kisses me sweetly. I can't be mad at him, but I am disappointed. Still, don't people say that this method is unreliable? Could enough sperm have already entered to find my egg? I hope so. I wish for it. I don't want to go back to the doctor.

He holds me close for a while before he puts on his clothes and prepares to leave. He stands at the far side of the room where the bathroom light illuminates his sturdy frame. He studies me.

"Thank you," I offer sincerely.

"You're welcome," he answers, grinning, dropping his head, turning around to head back out into the night.

10. Day 32

Peterborough in June is heavy with heat and the smell of blossoms flowing over yards, falling from trees, draping the streets. It makes no sense to work when the world is so full of life. I stop plugging away at my administrative tasks to walk over to the river. Suddenly I feel my stomach clench. I barely make it off campus and back to my apartment where I double over in pain. I crash into my blue bedroom and lie curled on top of the blanket. I am a couple of days overdue for my period when the blood drenches me. It hurts so much that I cry. I wonder through my tears whether the hockey man started a baby inside me that died today. The pain suits my sadness. It is unbearable, and the Advil seems to do nothing until I eventually pass out.

I wake up hours later, my body peaceful and bloody in the dark. It's still hot outside. Maybe I didn't get pregnant because he pulled out. Maybe it was because an older guy's sperm might not be as potent, like Hilary told me shortly after the night at the Roxy. Maybe I'm not fertile. Maybe I won't ever get pregnant.

Still, it feels like something came alive inside me. It feels like I'm closer. I definitely don't regret trying.

I was so scared that I wouldn't be able to fuck a guy. That I couldn't endure the feeling of submission in sex. But that's changed now. I chose everything that night: the bar, the hotel, the man. I planned carefully and entered into the engagement with free will. It made all the difference in the world. It was more human than another round of examinations at the fertility clinic. It was also a lot more fun.

11. Toulouse
(July 2008)

I have to go. It has to be this weekend, days eleven and twelve. I am with my family in a small village in France. The thirty or so houses are pieced together with large, old stones. The church is closed. The barn opposite the square has caved in. The bread shop stopped baking years ago. There are still cows and sheep in the fields though. And the one hotel on the east edge of town is open.

The only line I know in French is, *"Je ne parle pa français"* (I cannot speak French). If I ever say it to the people here, they decide I say it so well they begin speaking to me, thinking I'm being modest about my French. Either that or they figure nobody would be such an idiot as to come all this way without the ability to speak the language. But I have. As my family converses in French, I withdraw. It's lonely, but I like it. I am in my own world here.

I put on my shorts, jersey, pull up my socks, lace up my jogging shoes. I stretch my tight hamstrings then run out of the house. I run up and down the old, narrow streets, past wooden shutters and flowerboxes, through the square with the *oratore* and the bus stop, though I've never seen a bus come by or a speech made. I run outside the perimeter of the town, along the pastures. The fields of barley wave like water. The sun beams down on my working body. I am in continuous motion in a hot dream. From this place I feel I can do anything. I can fly right over these rolling hills. Skip along the lake at the bottom of the valley. Dive into the courtyard of the castle at the peak of the mountain. From this place I can dream myself pregnant. From this place I have the confidence to plan another sultry night. I will descend upon Toulouse two hours away.

I don't like to ask for help. It makes me uncomfortable to think of people troubling their lives over me. Wanting a baby changes everything. For this baby, I am willing to ask for things. For this

baby, I learn how to open my mouth and do what I want. When I return from my run, I head up to our bedroom for sit-ups. Hilary comes in and I tell her between curls that we've got to go to Toulouse on Friday, find a bar, find a man, and get pregnant.

She looks out the window and starts biting her fingernails. She is calculating the complications involved with my plan: asking Alma, her stepmother whose home we're visiting, to babysit the kids for a night; making reservations at a hotel; calling her sister to see if we can meet and get info on the bar scene; getting gas, money, maps, an overnight bag, plus sperm equipment: plastic syringe, lube.

She is fretting, but she always frets with new plans. She imagines everything that could go wrong before the benefits come into focus. There is, however, a particular resolute tone in my voice that dissuades her from commenting on the potential problems.

Potential Problems: The kids refuse to stay with Alma; Alma has plans with the monks at the nearby monastery that she cannot possibly drop in order to babysit; Hilary's sister decides that night to have a heart-to-heart conversation and process the first sixteen years of her childhood; the bar is closed; the men are all losers; there is no way we should further the genetic material of the asshole that wants to hook up with us.

Potential Benefits: Pregnancy.

. . .

I grew up on North American streets spread out in precise grids. A lack of imagination by the colonizers. The sharp angles, quick curves, bits of streets around Toulouse are hard for me to follow. I walk the route from the hotel across town to the bar. I try to memorize the path: a square with a carousel, a Laguiole knife store, an Italian market, a Chinese restaurant, a souvlaki takeout, the stone sculpture of two women caressing above subway escalators going down. I draw the shapes of the city on a piece of paper. I

check over my work. I'll be dependent on this map in the middle of the night.

Hilary's sister Mahalia tells us the dancing doesn't start up until 2:00 a.m. and doesn't end until 10:00 in the morning. Only 120 kilometres from the Spanish border, Toulouse has caught the Barcelona party vibe. We tell Mahalia only about wanting to dance. We eat dinner with her and her boyfriend at a small restaurant near the river. I purposely eat well and drink well, like in Vancouver. I am terrified. I don't know if the man will hurt me. I don't know if I'll chicken out. I don't know if he'll have some disease, forever changing the quality of my life. It's risky. I risk my life to make one. I accept the risk because I have only this small window of time, a few years, to create the most beautiful creature on earth. The other methods have been failing me.

You might think I'm being overdramatic. Or a fool. But I am operating on instinct. I am driven to create. I won't miss the chance. I eat and drink well to love the best of life before I risk it. And the best of life can definitely be found at dinner in a small French restaurant. We order the prix fixe, a stream of courses: sliced tomatoes in a vinaigrette, *magret de canard*, grilled asparagus, potatoes dauphinoise, a plank of cheeses—Cantal, Saint-André, Roquefort. We drink a bottle of red Côtes De Rhône to wash it down. And for dessert, a crème brûlée. I crack the surface and scoop the rich, sweet custard into my mouth.

Mahalia recommends that Hilary and I go to the small lesbian bar after dinner. It's more our speed than the disco I have planned: twenty-to-forty-year-old lesbians, couches, nooks, soft music. Normally it would be a good bet for us, but it's not a normal night. It's night number eleven, and that means I am just about to ovulate. I want the bar Shanghai.

Mahalia took me there a few years earlier during her party girl days (now in her mid-twenties, she tells us she's too old for such trivial pleasures). It has a mixed clientele of young straight couples

and gay men, all bumping up against each other on the dance floor. I remember dancing, laughing, and sweating until I left at dawn. There are two dance floors and a private men-only section downstairs. When I went before, the dance floors were packed and guys were hitting on me. They weren't rude though; they were almost gentle. I didn't mind. If anything, I was amused. I was starring in a comedy about cultural misunderstanding. At home, straight men rarely try to pick me up. Except at El Convento Rico where anything can happen, my jeans, button-down shirts, leather jackets, and barber cut mark my interest pretty clearly. I thought to tell them, *I'm not the object of your desire, I'm your competition for that sweet brown-eyed lady at the end of the bar ordering the green apple martinis.* In France, I was in disguise, a secret agent— watch out. Then again, maybe they knew exactly what I was, and it turned them on. There is the international fetish of lesbian, and the men of Toulouse are cocky enough to ask for it politely. Whatever the reason, it seemed like my best bet for sperm tonight.

After dinner, after lounging in the quiet little lesbian bar, Hilary and I make our way to Shanghai. It is only 12:30 a.m., but we figure Mahalia must've been exaggerating to say things don't get going until 2:00.

Shanghai is spelled out in a conglomeration of yellow, green, and red neon blinking over a side street. Two middle-aged men talk at the front of the door. They seem annoyed to have to break their conversation for a moment to let us in. There is a long black hallway before a room opens to our left. A rectangular bar stands immediately in front of us, and beyond it is the dance floor. Video clips flicker from a giant screen around the room, playing abstract images that don't connect with the music.

One tall guy in a black T-shirt dances alone on stage with the platinum blonde in the video. There is an older bald man with a big nose at the bar. That's it. Otherwise the place is empty, except for us. Mahalia was not exaggerating. Midnight is too early for Toulouse.

how to get a girl pregnant

I order an overpriced (ten euro) rum and Coke, but nearly spit it out. I think that the Coke syrup must have spoiled, but the bartender assures me that's how rum tastes in France. How could something as fundamental as rum have an entirely different composition when you cross a border? What else is not what it appears to be?

We watch the man in black. He's got a good, thoughtful forehead (not that I have given foreheads a second thought before) and dark hair, barely receding. The glasses are fine, the eyes look intact; he has a lean, lanky body, an average nose. The lips look funny though; they're pushed out too far. He's carrying the beat of the music on top of them. Maybe he thinks it's a cool bar attitude look. Maybe he's not thinking at all; it's his facial expression in standby mode. The lips are goofy, puckered but closed. I don't want a baby doing that. And why is he dancing by himself before anyone comes to the bar? That could be a sign of some kind of weirdness as well. *Nope, he's not the one.*

We turn to the bald guy with the big nose at the bar. He's bought a bottle of cognac for the night, ready to share. When we turn to look at him he motions to the bottle and back to us: do we want some? I nod and smile. I need a little buzz to get through the night, and I really need to get the taste of the rotten rum and Coke out of my mouth.

He offers his drink seemingly with no expectation of a return. A nice guy, not lecherous, maybe gay, late forties, early fifties. Hilary tells him in French that we're visiting from Canada. He raises his glass to gesture a small welcoming toast. I click our cocktails together. He's clean-shaven and has small blue eyes, strong cheekbones.

The nose is an issue. It extends from his brow several centimetres. Hilary turns to me and whispers, "How would we prepare a child to be in the world with a big nose?" A really big nose.

"It would be unfair," I answer, "we've got no experience." We would need the big-nosed father in this case to help the child live as a big-nosed kid on the playground. When you pick up a sperm donor at a bar, you pretty much give up the chance for your child to have those conversations with a father.

There is another problem. He's probably gay. Why would a man share his booze with two lesbians and expect nothing in return? He's definitely gay. I'm not going to get sperm out of a gay man at a bar. I accept the drink, the toast, the smile, and then move on.

A woman with long black hair, a leather miniskirt, and thick eyeliner walks in and sits beside me. I swivel around on my bar stool. She orders a beer, turns toward me, and asks something in French. I shake my head. "I can't understand. Do you speak English?" I tug on Hilary's sleeve for help. She's still chatting away with the big-nosed man. But the black-haired woman lights up and produces some English for me.

She asks about Canada. She wants to know whether bisexuals are accepted in Canada. She has a terrible time in Toulouse: her straight friends don't understand her desire for women; her lesbian friends accuse her of disloyalty when she goes out with men. She wants to know if there is anywhere in the world where she will be accepted. I can't promise her anything about Canada. I tell her to share her troubles with Hilary, who used to run bisexual support and advocacy groups.

I wonder if I'll be accused of disloyalty if I sleep with a guy tonight. It's tougher for femmes because they look like they could switch over. It makes people nervous. Butches are pegged as dykes with or without a woman at their side. If you're a butch and you sleep with a man, is that betrayal? It's just uncommon. I don't think they will question my dyke credentials though. They might think it's a little gross. I can live with that.

how to get a girl pregnant

The black-haired woman interrupts my thinking, assuring me that we'll have a good time in the bar, that the men will be respectful of Hilary and me as lesbians. "They won't try to grab you." It would be a sweet thing to say on any other night.

"Oh no," I'm worried, "We were hoping to pick one up tonight."

She practically chokes on her beer. Does it really seem so impossible? Will the men avoid us?

"Why?!" she wants to know; she is flustered. It's a bad sign when even the bisexuals can't comprehend a little bisexual behaviour. I look way too gay for this.

"For fun," I say and pick up Hilary's hand, leading her to the dance floor.

. . .

It's two hours later before a reasonable selection of sperm donors are moving on the dance floor. Hilary and I dance near each other, not together like a couple, but more like friends. I want to appear available. I want Hilary to go back to the hotel. How am I ever going to get sperm with my girlfriend here smiling at me? It doesn't feel right. It doesn't suit my mood. I want to feel anonymous, alone, hunting for a lover in the dim lights of a bar. I don't want to know anyone, or have any responsibilities. I want all of the advantages a bar in a foreign city has to offer. She's messing it up, looking at me with her enormous eyes and little grin.

She asked me earlier if I wanted her to leave, but I didn't have the guts to say yes. I got scared. I don't want to get hurt. I am a small woman trying to bring a man to bed with me in a far away place and I don't know the language. So I told her not to leave. How can I be a sexual adventurer and still want someone to walk me home? It's ridiculous. I've put myself into a situation that I don't want to be in, and now I'm in a foul mood.

It doesn't help that none of these men seem right tonight. Too young, too gay, too good-looking, too intimidating to approach. Either I don't have enough points for most of the guys in this bar, or I don't think I have enough points, rendering me frozen in my dance step, back and forth, one-two, one-two, one-two. There are others—too old, too hairy, bad teeth, too bald, too drunk—that I have more than enough points to get. But that's the problem, I've decided they don't have enough going for them to be the father of my baby. I need someone just right.

When you look at sperm donors on a webpage everyone looks pretty good, clean and clear cut, all specifications situated perfectly into a grid: height, weight, age, eye colour, hair colour, medical history, jobs, interests.

You don't have the opportunity to see their goofy dancing, or the way they twitch their noses to the left, or whether hair grows on their ears. You also don't know whether they'd turn you down flat for a drink, or a kiss in the corner. Bars bring out the insecurities and unpredictable judgments you didn't know you possessed when you looked at a chart of sperm from the bank.

It's too complicated with the beat of the music pounding in my chest. I can't breathe. I want to go home. *Stop thinking about it. Keep dancing. Keep smiling. Keep watching the men.*

We're somewhat surrounded by a pack of handsome dark-haired, dark-eyed men. If we were in California, I would assume they were Mexican. But in Toulouse I have no idea where their brown skin comes from. They are young, like twenties and thirties. There is the pretty boy, hair gelled up and dangling over his long eyelashes. He's got a cute grey vest over a fluffy white shirt. His buddy is dressed head to toe in white, with nice muscles under his T-shirt and a slightly crooked Mediterranean nose. He looks like a boxer. There's no way they would go for me. Too young, too beautiful. I feel old and flabby next to them. I feel like a mannish woman that such boys would make jokes about.

Near the bar I point out to Hilary a man with small silver glasses, mid-length wavy brown hair, a button-down shirt, and corduroy pants. He is out of place. He looks like a professor. He might go for me. Hilary agrees. I start to make a move toward him, when he staggers off his bar stool and just about crashes to the floor. The man next to him helps him back up to his feet. The professor is too drunk. If he was drunk but still seemed like he could perform that would be one thing, but whatever sperm he might have, have already called it a night.

I spot a silver-haired man a few seats over from where the professor crashed. He's wearing a grey blazer and dress pants. He has a wide face with bow-shaped lips. I could look at that face on my child. I watch him for a while and he seems to be alone, watching all of us dancing. I've got my relative youth on my side and I'll use it. It worked the last time.

I tell Hilary that I'm off to try with the silver-haired man. I push through the bodies that periodically knock me back. I hate being a short person in a bar. Nobody sees you; everyone accidentally runs into you.

I meet his eyes. He looks up and raises his eyebrows in a question, *What do you want?* He looks curious, open, ready for an idea. He moves his hand down to his knee, opening the blazer slightly, and showing his slim waist. *Nice.* I could hold that waist. I point to the dance floor. I tilt my head, motioning to him to come with me.

He shakes his head no. He's not interested.

"Oh, okay," I mouth, like I hadn't wanted anything at all. Like I don't care. Like I haven't waited the last two hours to find the one guy I thought might work.

I go back to dance near Hilary. Now I'm really miserable. I want to somehow blame my slow night on Hilary because my father taught us to blame unpleasant situations on someone. They

have to be someone's fault. It's a terrible practice that generally only makes the situation worse. On a good night I catch myself and stop doing it. I turn the situation around.

I turn and grab Hilary. I give up on the men, on the pregnancy plan, on night eleven and instead dance with my girlfriend. We are, after all, on a vacation in France, surrounded by hundreds of sweaty bodies. We are alive and moving, and I'm not such an idiot as to lose the night. I take her hand and pull her down to the basement room.

I would not want to be in this room under any other circumstance—a floor beneath street level, a black room leading into a tube. The tube has low vaulted ceilings covered in mirrors. I'm afraid to know what the original use of the tube was.

Tonight it is packed with hot bodies bouncing to the music. I reach for my girlfriend's hips and move her close to me. Our thighs interlock in rhythm. I kiss her lips, her face, her neck. I am thrilled to be dancing with a summer crowd in Toulouse. The other dancers push against us. It is tight and wet. If I close my eyes I am twelve years old, swimming in the waves of the Pacific.

When I open my eyes, I see a man's face looking back at me on the other side of Hilary's body. I blink. It's the boxer from upstairs. His group is dancing around us, the pretty boy and the others surrounding us on one side in a U-shape.

The boxer smiles. I smile back. Hilary whispers, "He's got his hand on my ass." Before I can answer his lips press against mine. I open them. I have my hand on Hilary's waist. The boxer has his hand on Hilary's ass. He has his lips on mine. I push my fingers along his jaw, then to the back of his head, the close shaven hair gripped in my fist.

All we had to do was be a couple of dykes in love to lure a man, to catch the boxer. It figures, as soon as I give up, as I turn my back on the men and return to myself, to my proper place beside my lady, they're interested.

"Let's take him back to the hotel," I tell Hilary, and she translates an invitation to the boxer. A giant smile spreads across his face. He gestures that we should go first. Out of the corner of my eye I catch the pretty boy giving him a high five as we exit.

Out on the street, I take another look at him. He is in his mid-thirties, tall and strong, not super muscular but toned up. He fills his tight white pants and T-shirt. He has black hair and pretty dark eyes that squint and shine when he smiles. I could love a baby with those eyes. He has more points than me if I was alone, but I'm not alone. I have bonus points for being queer. He is amazed that we are real live lesbians.

"How long have you been together?" he wants to know. "You've been lesbians for how many years?"

The more gay we are, the more authentic, the more exciting the fantasy.

We ask if he has been with lesbians before. He has tried several times to sleep with couples, but none have ever allowed him to. He is beaming in the streetlight with his good fortune. So am I. We have each won the lottery.

"What's your name?" Hilary asks him in French.

"Bob."

"Like Bobby?" Hilary wonders.

"No," he shakes his head, "My real name is Bala. I say Bob as a nickname. It's Turkish."

He puts each of his arms around us and we walk together, the three of us, down the path to the hotel. I am so alert, so focused, that I remember the directions by heart.

. . .

At the hotel room, the three of us sit up in the bed in a circle, not entirely certain how to start. Hilary announces that ground rules are necessary.

Here are the rules:

1. Karleen can mess with Hilary.
2. Hilary can mess with Karleen.
3. Bala can mess with either of us, but he is only allowed to penetrate Karleen.

Why can't he penetrate Hilary? he wants to know. Hilary asks me, and I clear things up. "Because you're a lesbian," I say.

"Because I'm a lesbian," she answers. The truth is that she's a seasoned bisexual, who has seen more than enough sperm in her life and has no desire for any more.

We are confusing and contradictory lesbians for the boxer.

Bala spends the next few hours trying to penetrate Hilary. Of course he wants the one thing we say he can't have. As in every threesome, there are complicated dynamics. I want Bala's sperm, Bala wants to penetrate Hilary, Hilary wants me to touch her.

It starts simple though. I am to make love to Hilary, and Bala is to join in when he feels inspired.

I lie down, climbing beside Hilary. I trace my fingers up and down her jeans, then under her soft black blouse. I rub her creamy tummy with the palm of my hand. I push my face down into it. I love the smell of her skin, sweet like milk. I begin kissing her. I move up, take her breast into my hand, and then into my mouth. She moans quietly when I lick her nipple, and jerks sharply when I bite down. I try to forget that he is watching. I try to focus only on Hilary.

When her whole body begins to move under mine, and I know she needs the relief of my fingers inside her, I tear off her jeans. I work my hands roughly inside and she gasps, then exhales, heavy and full. She knows my touch. Her breathing quickens. I am beating inside her. I am releasing the fear and worry from my body, and pushing it all up inside of her, as I have done so many

times before. She takes care of me, and grips the sheets in her fists as I pound. I don't slow down until I feel free and light and wild.

When I stop moving, he starts. He reaches toward Hilary's breasts, and pulls one into his mouth. I continue working her with my hand. Her body flexes and tightens, contorting against ours. He unzips his jeans, his cock is hard and he takes it into his hand to rub it. He says something to Hilary in French and she answers. They go back and forth on some issue.

"He wants to fuck me, and I told him no," she shakes her head. "Then he asked for a blow job, and I told him no again. What do you want to do?"

Aw, fuck. Why do guys always want blow jobs? I mean, so do I, but I can take good care of a woman first. He's five minutes into this, and that's all he can come up with. *Fuck. All right. Give it here. Let's get this thing over with.*

I look at his dick and it seems enormous. It's definitely bigger than the guy's in Vancouver. How am I going to get that thing into my mouth? "It's so big," I tell him. I figure that's what guys like to hear. Hilary informs me that it seems pretty average to her but she nonetheless translates my compliment.

Bala laughs, and says something back in French. Hilary translates, "He thinks you must not have seen one before."

"Well, that other guy wasn't as big," I say under my breath as I size it up for this blow job. Hilary translates again. "Jeez," I say, "you didn't tell him what I said did you?" But, it's too late. Bala is questioning her: Which guy? When? What is this all about? he wants to know.

I lunge for his dick and take it halfway up into my mouth. He forgets his questions. He rolls his head back, squeezes his eyebrows together, starts panting and swearing. His thighs are locked under my hands. I move my head on and off and try not to choke. I prefer the neutral, squeaky taste of a dildo, but I can handle it. I take

control of it and of him. I've got the tool in my mouth, and I will get it ready.

His whole body moves in a rhythm to my work. When I feel his energy rising to the edge, I start to panic. I absolutely don't want him to come into my mouth, for several key reasons. I take him out abruptly and he looks up at me, alarmed and helpless.

Can he penetrate Hilary, he wants to know.

"No," Hilary tells him once more. This is getting tedious. I'm feeling jealous of his attention to her, and she doesn't even want it. I want the father of my baby to be attracted to me. I don't want to feel ugly tonight. I want him to want me. I want to be able to tell the child that his/her father was a strong, beautiful man who made love to me one night in France. That's an okay story to grow up with. I don't know why I need a better version of the affair than the one that's unfolding. It shouldn't be important, as long as I get the goods, but I can't shake the feeling. I swallow it. It's not going to stop me.

Hilary explains to him that he can penetrate me, and he nods. The issue of a condom does not come up. Do guys give a second thought to condoms? Hasn't there been a century of ads/education/warnings? He won't mention it if I don't mention it. This part is easy.

I turn onto my stomach. I squeeze my eyes shut. I am preparing myself like I would at the doctor's office for a shot. He is on his knees behind me. He pushes himself inside me. It's huge and it hurts. It reaches all the way up to my belly button. I'm not sure I can bear it, and I'm hoping he'll be quick about it. He swings himself heavily inside me, giant but slow thrusts. I grit my teeth. I don't think there's enough room. *Ouch. Fuck. Please finish up*, I plead inside. And he does.

He is quick about the business, and proceeds to be quick about everything else for the rest of the night. He cannot sustain the

patience needed to make Hilary come. He cannot give up asking her for more. He cannot get me off. He is a little boy, valiant and ready with his sword, with little idea of how to use it. I decide then that older men like "Vancouver" are definitely the better bet for a good, experienced top.

My favourite part is in the lull between lovemaking, when he lies down beside us, his long body on display. There is no question that he has a beautiful body. I admire his muscular thighs, soft chest, dark nipples, broad shoulders. He talks about Turkey, about the mountain that overlooks the city where he grew up, about his immigration to France, about his job at a café, about his hope that Obama will win the election. His eyes are beaming. Every once in a while he laughs and shakes his head. He can't believe his good fortune, sleeping with two lesbians tonight.

Shortly before dawn he dances off down the hallway, into the elevator, and out the front door of the building. We watch him below us, strutting alone on the street, disappearing around the first corner.

12. The Photograph: A Visit to Bala's Café One Week Later

There is a photograph of Bala, Hilary, and me. We're sitting on the steps of the café where he works. I am the only one smiling: a big California, teethy grin. I am wearing a long-sleeved navy tailored shirt. It's one of my favourites. I want to look my best. Bala sits tall in the middle. He is showing off for his co-workers. The lesbians he had sex with, and then told the cook and busboy about, have shown up. He wears a white collared shirt, dark work pants, Italian shoes. The sun is so bright that his beautiful eyes are reduced to a line of squinting across his face. The sun also reveals thinning hair, previously hidden in the dim lights of last Saturday night. (That's okay, I reassure myself, my brothers both have thick heads of hair well into their forties. This should balance any genetic hair loss issues. Besides, baldness is supposedly passed through the mother's line.)

Hilary sits on the other side of Bala in a sundress. She leaves a few inches between herself and Bala. She looks straight at the camera, forcing her eyes open despite the sun. She looks like she wants to say something. She looks uncomfortable in the pictures. She is perhaps intruding? "We should take one of just the two of you," she suggests. Should the baby have a record of his/her pure biological parents alone together? No, I decide, we three worked together to make a baby, even if Bala wasn't precisely on board. Besides, I am still in secret operations mode. I don't want to do anything suspicious.

In the photograph our faces are small, part of the background. Hilary and I are two of thousands of tourists to hit the South of France in any given summer. Hilary kept nudging the waitress who took the shot to come closer with the camera. It could be our only photo of him. If I'm pregnant, it will be the only image of a father that we have for the child.

13. Heartbeat

Salt Lake City, Utah (August 2, 2008)

I wake up to a small, white dormitory room. The air conditioner is cold and loud and the desert outside is far away. I'm here to present a paper at a Latina conference, but mostly to hang out with old friends. If I manage to open both eyes, and keep them open, I might make it to the first session of the day. I close them again and drift off.

Toulouse. The Shanghai bar doesn't seem real. All I see are clips of music videos and bright lights lining the dark basement walls. Did I really sleep with the boxer? It seems absurd from here, a women's conference in the Southwest, where I'm supposed to be a big dyke. I can't tell anyone. I cringe, but I still don't open my eyes. I want to go to sleep again, but my bladder has other plans. *Damn.*

I pull myself up and head across the grey industrial carpet to the cool tiles of the bathroom. I sit on the toilet and am just about to pee—that great feeling when you know you've made it to a toilet and can release—when I force a quick stop. *Shit.* Today's the day. Exactly fourteen days since insemination. My bladder plans a revolt, but I squeeze my legs back together and search for the white plastic package in my toilet kit.

I rip it open (and without any jar in sight) stick it underneath while I pee, missing it half of the time. *Damn.* I let it drop to the floor when I finish and bend over. I close my eyes again. I'm exhausted from the jetlag from France. I wonder if I could fall asleep right here on the toilet. It wouldn't be so bad. I lean my head back against the wall for another minute until my back gets too uncomfortable against the piping. Finally I pick up the test and head to the sink. I flip on the light switch to get a good look.

That's the negative line as clear and solid as ever. I put it down on the sink and turn on the tap. I cup the water in my hands and spread it over my face. Nice and cold.

I look back down at the test and notice a faint line perpendicular to the first, turning the negative line into a positive sign. *Whoa, what's that?* I haven't seen that before. But it's so faint. I hold it three inches from my eyes and it's still faint. The negative line is much darker, much more definite. Does the positive line have to be as dark to count, like the OPKs (ovulation predictor kits)? Or does its mere existence mean what I think it means?

I look at myself in the mirror and check my eyes, my skin, my face, my shoulders to see that I'm real. I exist. This isn't a dream. This is a positive pregnancy test. Even the faintest of lines counts, ninety-nine percent guaranteed. I smile at myself.

No fucking way.

I did it. I fucking did it.

I get right up close to the mirror and whisper the words at myself, "I fucking did it." That's when I see the light shine off one strand of hair above my left ear. I turn slightly and look again. It's silver. I dig for it and hold it between my fingers. A silver hair. The first one. I'm thirty-six and I've got a positive pregnancy test and a silver strand of hair.

My hands are shaky when I find my cellphone stuck inside the crumpled jeans on the floor. I dial Hilary and announce, "Baby, I'm pregnant."

. . .

We, the women of the conference, head out that night, drive past the giant, glowing Mormon temple, to a grey warehouse with a bar area fenced in at the front. It's costume night, a Halloween themed Saturday in August, just for the heck of it. Queers are like that. Any excuse to wear costumes. There really should be more than one

Halloween per year. We can be any weird colour, texture, fantasy we can imagine, without feeling like a target. We can disappear into the night.

We dance by a purple clown and a dead butch cowboy. My friends bounce and swirl and I smile. I've got my secret hidden inside my belly. Two cells dividing, four cells, eight cells, sixteen, thirty-two, sixty-four, jumping to thousands, tens of thousands, millions.

I dance with my hands balled into fists. No sweaty drunk is going to knock into me. I dance with a soft step; I want to rock my baby gently into life. I dance until there are only small movements of my muscles, my feet barely shifting to the beat. I rebuff the eleven friendly attempts to buy me alcohol, and answer their quizzical glances with a laugh. It's my secret for now. And once the music gets too loud, when the tequila has soaked into the swaying dancers, when last call and final hookups are declared, I head out under the moonlight. I sit on the curb with my buddies and eat a rich, warm quesadilla from the taco stand.

Toronto (August 27, 2008)

Irena tilts the computer screen around so that Hilary and I can get a look. The little baby is nothing more than a small mass of tissue, a tiny white doughboy floating in space. But there is one unmistakable feature. The heartbeat. A bright light beating vigorously in the middle of the screen. One hundred and six beats per minute. I see my baby's heartbeat and feel my face flush. I've taken at least seven home pregnancy tests to make sure that the baby is still there, but a baby is something too extraordinary to believe based on a little plastic contraption. With the image, it's finally real. I'm not alone anymore. I'm tied to that beating heart.

The three of us watch the baby together. Irena smiles at me. She's been rooting for me from the outset, and I prayed we'd share

this day together. "The length of the baby is zero point forty-six centimetres. You're six weeks and one day pregnant," she explains.

"Hmm, no that's not quite right," I calculate, "Are you counting since conception or since my last period?"

She pulls out the wand, raises and lowers her shoulders to say she doesn't know. She looks toward the door. "Doctor Meredith will go over the chart with you."

I dress and Hilary and I head back out to the couches. Dr. Meredith enters the waiting area with her clipboard and calls my name. When we approach she flashes a mischievous grin. "Congratulations," she says, "and on your month off."

"We were in France," I offer as explanation. Isn't that what you're supposed to do in France? Find a lover. Do transgressive activities. How many times will I need to tell the story? I should begin rehearsing. *I found your father in France. I found him late one night, dancing. It was a city in the South, a maze of tiny streets* … Meanwhile, Hilary has made plans of her own with regard to the father's identity. She's got two estimates from detectives in Toulouse to find out Bala's full name, birth date, and city of origin in Turkey. This way, the child could someday locate him if s/he desired.

Dr. Meredith escorts us inside her office and closes the door behind us. She sits down behind her desk, clasps her hands together, and asks, "Were you safe?"

I'm speechless. What does she mean? How exactly could I get pregnant if I was safe? Is there some crucial gap in my sexual education that could've protected me? I look at Hilary.

Hilary looks back at Dr. Meredith. "No," she pauses, "we didn't know him."

Dr. Meredith nods her head, and assures me that she will run tests to make sure I'm all right. No diseases.

Thank God Hilary is here to understand and translate for me. I feel like I'm in a room with two women who know about the world of men. Sometimes I've got no idea how to participate. It's amazing I've made it this far.

Dr. Meredith looks down and examines the data from the ultrasound. "So your last day one was on July seventh. That makes seven weeks, one day?"

"Yes, that's correct." Seven weeks, one day. The baby book says my baby is half a centimetre, about the size of a blueberry.

"Hmm," she says, studying the paperwork, "the size of the baby is smaller than that. The photo shows six weeks and one day. You probably just conceived later than you thought."

I grin and shake my head at Dr. Meredith. When you're a dyke, with no superfluous sperm in your social calendar, there's no chance you've got the date wrong. It was July 18. It's possible the sperm could've hung out for a while if I ovulated later, but I don't think it would've lived for another whole week. The doctor's got it wrong.

"No, for sure it was July eighteenth," I correct her.

She smiles. "Well, the flights and time changes could've altered your cycle," she pauses, "You'd be surprised how much effect that sort of thing can have on your body."

I've studied enough human development to be suspicious of her numbers. My baby, not even two months old, is already being measured and judged against rates of normalcy. The baby is a couple of millimetres off, that's all, what's the big deal? I was the second shortest kid throughout grade school.

"Yeah, but isn't there variation in fetus size?" I challenge the doctor.

Dr. Meredith takes a deep breath, "At this early stage, there's very little variation," she gathers up her papers, "but let's not worry about that at this point." She looks up at me, "Your cycle was

probably just delayed. Come back in a week, and we'll check the size again. That's the procedure."

The victorious bounce in my step (that I've had ever since I read my positive pregnancy test) fades into a shuffle down the hallway. My eyes are glued to the grey zigzagged lines of the carpet in front of the elevators. I count days, weeks: seven weeks, one day equals fifty days, equals a bigger fetus. Did I count wrong? Can I recount it in a way to make it right? Am I missing something? Is the doctor wrong? She said not to worry. I shouldn't worry. Thirty-one days in July, right? It's not one of those months with fewer days? Maybe it only has thirty days; maybe we've made a mistake there and that would give me an extra day. Could that strong boxer's sperm have lived for an extra six days? Is that possible? And somewhere over the Atlantic Ocean, probably during the turbulence that makes my heart pound, my egg froze up, retreated, decided to wait a few more days until it was safe again to come out, to jump free. That's reasonable as well. Hilary and I reassure ourselves of these variables on the elevator ride down, in the car ride home, and late at night when she turns over and I kiss her neck and hold her, with our baby tucked between us.

What's hard are the long days working when the worry creeps up, despite Dr. Meredith's direction. Both Hilary and I have jobs tied to computers, where the omniscient Internet lurks on sidebars, calling out to us.

It's hot. My peach-coloured office on the third floor of the Victorian soaks up the sun. I place a fan three feet from my perch. I turn it up high and submit to the blast of wind against my sweaty body.

I'm supposed to be finalizing my syllabus for classes that begin this week. Instead, I'm searching websites that assure me that the presence of a heartbeat means a healthy baby. How many websites do I need to see to trust that the baby's okay? A Dr. Landon approves of the medical information provided. An Organization of

Yukon Doctors predicts a ninety to ninety-five percent rate of fetal success once a heartbeat is established. That's good. Those are great numbers in everyday life. A- to A+. Gold star. Although five to ten percent chance of death isn't so reassuring. It's way too high when mortality is the question. With statistics, it's all about the question. I'll be tied to these baby websites until the kid is born.

I tentatively punch in the more worrisome words: *small fetus size*. A woman eight weeks pregnant holds a fetus of the size of six weeks and asks for advice. She is told not to worry, that the dates are probably wrong. Another site explains that there can be small normal fetus sizes, and that eighty percent are fine. That takes another ten percent away from my chances, but they're still really good. Another site tells me that the baby could be born smaller than ninety percent of other babies. Or, I might have IUGR (Intrauterine Growth Restriction)—with placenta problems, disease, chromosomal abnormalities—caused by high blood pressure, chronic kidney disease, advanced diabetes, anemia, infection, drug abuse, cigarette smoking . . . though I think I would've noticed these. I don't have these. I am okay. My baby is okay. *Stop.* This technology is not helping. Each new tab, each click of a link offers another pathology that grows monstrous. *Stop.* Step away from the keyboard. Where is that syllabus? Remember, eighty to ninety percent chance that the baby is okay. I am okay. My baby is okay. Get back to work.

September 3, 2008

Irena isn't in the fertility clinic today so they usher me up to the sixteenth floor for the ultrasound. Another Eastern European woman with long dark hair and blue eyes is my technician. She is tall with round hips and tummy. Her body looks soft and her eyes are warm when she asks me to remove my clothes and move into position. I feel lucky to get someone so motherly on the day I need reassurance that my baby is okay. If anyone can calm me down, it's

her. I don't mind opening my legs to her. I would cuddle into her arms if she were lying beside me.

She pushes the smooth, cool wand inside me, and I try to hush my instinctive gasp. I breathe out slowly and look over to Hilary. I don't know why they can't figure out a method for showing me the images of the baby at the same time as the technician. Two computer screens would do the trick. Or better angles. It can't be that difficult. Instead, I depend upon my analysis of Hilary's expression as she observes the images over the technician's shoulder.

She is searching. The skin around her eyes tightens. She follows the vague curves of tissue illuminated onscreen. Her head tilts slightly. It takes a while to find familiar shapes, to decipher the images. She studies the landscape. She could be looking across the gorges in France, spotting a castle tucked into the ridge above a river. I am waiting for the moment of recognition, when her eyes stop moving and lock onto the silver heartbeat. But her eyes don't stop moving. Her eyebrows fold into a frown. She follows a new curve, and then another, and another still.

I can tell that she is still searching, but I am impatient. "Do you see the heartbeat?" I ask.

She doesn't answer.

"Is it beating fast?"

Nothing.

"What do you see?"

She is still chasing the images, looking up and down, her eyebrows scrunched deeper into her forehead.

The technician. The beautiful, motherly technician breaks the silence. "I'm sorry," she tells us. She pulls out the wand and finishes punching her observations into the keyboard.

"What?" I don't understand.

She shakes her head. "The doctor will talk to you."

"Babe," I ask, "what do you see?" The technician might not be allowed to talk to me, but my girlfriend can.

Hilary is frozen, with a confused gaze. She cannot see anything familiar. "I don't see the heartbeat," she utters. "Where is the heartbeat?"

The technician, who must by regulation remain silent, has wet eyes that I catch even as she tries to hide them. "I'm so sorry," she mutters once more.

She gathers up the printouts and turns to leave. She hesitates as she opens the door. She speaks facing the far corner of the room. "I've had five miscarriages. Every one of them hurts terribly." And then she exits.

14. Old Blood

I am walking around with a dead baby inside me. I am teaching classes. I am attending meetings. I avoid looking at the photographs of my colleagues' children smiling on their desks. I am commuting beside fifty others on the Greyhound bus. They don't know that my stomach is swollen. The doctor said it could come out at any time. I will have no warning. I carry Advil and extra pads in my backpack. I am not really sure what is required.

The baby that Hilary, Bala, and I made never got bigger than .46 cm. Its heart stopped beating and it is fading into the other tissues of my body. If I weren't hanging out at fertility clinics, I wouldn't even know that the baby is dead. I'd find out when the contractions started or, if it stayed inside, at the first twelve-week ultrasound. Hilary and I would've been smiling and holding hands, filled with excitement at the image of our baby, only to find darkness. We never would've seen the baby's heartbeat.

I sit in my office with the door closed. I can maintain my smile for my students and colleagues for the required schedule of classes and meetings, but then I retreat. It's quiet here. Books and papers are piled up around me. Family photos and social justice posters line the walls. Outside my office window is the road heading off campus. I would be sitting in the middle of the road if this building weren't here. I watch the crowd of students huddle under the shade of the building across the way, waiting for the next bus out.

How does the body know to let go? How does the body understand that the configuration of new cells isn't working?

My mother miscarried her first child. A girl. She was going to name her Suzy. That's all I remember of the story. My dad remembers a late night, a bloody bathroom, an unformed creature. He doesn't remember how my mom felt, or what she needed. I need her right now, to tell me.

Because she miscarried, I figured that I might miscarry. I don't know if there is any correlation between mothers, daughters, and miscarriages, but it seems like there would be. She created me. We are the most similar of animals. The fleeting stories of my mother's body are the closest I get to understanding my own.

I lean back in my chair and put my feet up on my desk. I am wrapped up in my fall coat with the red silk lining. I cross my arms, clutching both elbows, holding my body together. I don't know what's going to happen. I don't know if I'll ever have a child. I know two things. One: I have proven that I can get pregnant, so there's no reason why it can't happen again. Two: I need to find more fresh sperm, because I'm too broke, too discouraged, and too worn out to try frozen sperm again.

September 10, 2008

What comes first is old blood. Ancient burgundies and browns. How does blood become so old in only a couple of weeks? There are bits of dark red jelly that remind me of the remains you'd find after an airplane crash, only I've never seen an airplane crash. But when I was thirteen, I was on a train that hit someone and that's all that was left of him on the station platform.

And then the pain starts, so many hours later that I don't think it is coming. Big, heavy belly waves building and fading. The ibuprofen is useless. Hilary suggests moaning. And so I cuddle into a blanket and pillow and fill the room with deep sounds. When I feel some new piece release from my body I leap to the bathroom. I bring my fingers down to touch the child. I give birth to handfuls of unrecognizable blood and tissue. Somewhere there is a small fetus. There is also a whole factory that my body was building to nourish the child. All of the pieces fall out of me.

I should be bawling my eyes out at the death pushing out of my belly. Instead, I am in a state of wonder over the rhythm and pain of my body at work, and the life that I made in six weeks.

Karleen Pendleton Jiménez 139

15. Four Lovers
(October 3, 2008)

"What about that listserve?" Hilary asks as she loads the dishwasher.

It is a Friday night after a long week of work and I am tired. My stomach is swelling up and I know my period will follow shortly. Another wasted egg. I am sitting with my head down on the kitchen table. The wood is cool against my cheek. I can't decide whether to eat a bite of chocolate, or ice cream. I can't decide whether to get up and turn on the radio, or go read a magazine, or listen to Hilary. I can't decide anything, so I sit unmoving. I take a big, deep breath and exhale.

"What listserve?" I try to sound interested.

"The one for queer parents," she responds.

Oh yeah. That's right. My head pops up. We had looked at it a couple of years ago when we first started the process. The website was new then, and only had a couple of posts. That was when I was only in the market for Latino sperm and nobody qualified. But these days I'm open. I've left preferences behind. Is the man alive and breathing? Do his sperm swim? Okay, not quite, but almost. It's worth another look.

We hop back online. Hilary sits in the driver's seat, controlling the mouse, and I lie on the floor of her office. She reads to me.

"Synernacinc: I am a single gay man. I am a businessman. My roots are Irish and English. Fitness is important to me. I enjoy bodybuilding and playing squash. I am five-ten and a hundred-and-eighty pounds. I am looking for a lesbian to co-parent a baby with, maybe joint custody? I want to be known to the child as the father, because family is important to me."

"I don't know about that one, Hilary." I'm throwing a rubber ball up into the air and catching it. "He sounds like a Ken doll or something."

"Too much work," Hilary says, and shakes her head.

"What do you mean?" I ask

"We'd have to sign up the kid for sports teams," she explains, only half-joking, "Hockey practice can start as early as six a.m. Then there's baseball, soccer, basketball…"

I shudder. "You're right. I'm not a morning person. Next."

"Alfonso8: I am a thirty-two-year-old Italian gay man. I am in a loving ten-year relationship. We have thought about adopting, but I'd really like to have a biological child. (Note: Also, my mother would love any child that we raise, but I know in her heart she'd really love it if I had a biological child, not that she has so much influence over our decision-making.) I am a chef and my husband runs his own computer consulting firm. Being a chef keeps me out most nights of the week, and it would be really hard to have full-time custody of a baby. I want to do a good job as a dad (certainly better than my dad did), so I'm being realistic; it would be more ideal to share the work with another couple. Would you be interested in being that couple? P.S. It would be great if we could live in the same neighborhood. We have a condo right downtown in the Village."

"What do you think of this one?" I ask, sitting up.

"He sounds kind of fun."

"Yeah, I like the quirky comments about his family. Feels human." I think for a second how sad it is that my family is so far away, and that my mom is dead and I've got no grandma to offer a baby. "And it would be nice to have his mom in the picture."

"Plus the chef thing," Hilary pauses and turns, "Good food at family events."

I smile. Good food is definitely a bonus. Sperm and a gourmet meal. What more do we need? "Well, we could email him."

"Wait a second," Hilary says, "listen to this."

"Latinoqueer72: I am a thirty-six-year-old Mexican-Canadian immigrant. I came to Canada because it's a great country that lets you be gay and love your boyfriend in the open. I have a boyfriend of three years, and we adopted a puppy six months ago. I run an import-export business. I am an uncle to three nephews and two nieces. I love them, but I want to have my own kids too. I am not very religious, but I believe in God, and I was raised Catholic. I speak Spanish, English, and a little bit of German. I like listening to music in my car, and going out dancing on the weekend. I like reading and watching movies. If I had a kid, I would help them in school because it's important, but I would also find things that the kid liked to do. I want my kid to enjoy their life."

I am standing up now, reading over Hilary's shoulder. *Is this guy for real?*

Hilary doesn't need to ask me anything. She presses reply and we compose an offer to Mr. Latinoqueer72.

. . .

I jump up the next morning to check my email. There are messages from Amazon.com to offer me deals on books. Land's End will provide me with free shipping, but only if I send in my order today. There are two notes from students with explanations regarding their absence from class on Thursday. I make Hilary and me poached eggs and bacon and sip tea and eat toast and listen to the CBC radio game show. I do everything slowly and waste at least another hour and a half. It's after 11:00 a.m. now. Even if Mr. Latinoqueer72 went out dancing last night, he'd probably be up by now. I check the computer again, but there's still no reply. I click on *Mailbox* (which updates newly received mail), and then once more to see if he just happened to send in his response in the last two minutes since I opened my email. I go to click again when Hilary rubs her hand into my back and slowly turns the chair around.

She points to the other end of the hall at a beam of sunlight shining in from the front door. "Look," she motions, " the sun is out. We should go for a walk."

I debate for a moment whether or not I can leave the computer. I click *Mailbox* one more time. Nothing. I put on my navy coat and follow her out the door into the cool fall day. We walk east toward downtown, then south into Kensington market. I get a coffee at the little silver café next to the bookstore, then search for the next book that I really must read but have no room for on my shelves. I buy a zine by a mixed-race poet with a tribute to Obama, complete with a cut-out paper doll of the man, and a "Yes We Can" to-do list for Canada.

I need to set a couple things straight. First, the phrase "Yes, we can" was invented by the Chicanos, the United Farm Workers Union (*Sí se puede*) in the early 1970s, not by Obama. Second, I've gotta admit that I was a Hillary supporter until she stepped down. My first allegiance will always be to the strong, smart women. That said, sometimes you need to hedge your bets. Sometimes you have to let go, and put your trust in a decent man. To be honest, I really hope he wins, but I can't imagine that the same country that would elect Bush would then elect an intelligent man. I'm not holding my breath.

Hilary and I manage to leave the bookstore and head down Kensington Avenue where the trim on the Victorian houses is painted in bright colours, and secondhand skirts and sports shirts hang on outside racks. It is Saturday and there are deals to be found in every corner of the Market. We go through a bin of silk scarves. I touch the purples and blues. I brush a lime green one across my cheek. Hilary buys the fuchsia one as a future gift for Maya.

We walk down past Dundas to Queen Street. Along the way we run into Tim, an acquaintance of ours who we usually find at political rallies or educational events. He has defined gay activism in Toronto since the 1970s, and has always been an important

mentor to me, but we haven't shared so much of our personal lives together. As he and I talk, Hilary slips behind him and mouths dramatically, *Ask him for sperm ideas.* I am trying to focus on Tim and not alert him to our side conversation. While we hash out what's new with our jobs and political interests, I mull over Hilary's suggestion. Heck, what do I have to lose? At this point, I want a baby more than I want my privacy.

I mention to him that I am in the market for Latino gay sperm, if he happens to know anyone. His eyes widen, and he smiles. It's an unusual request, but I can see that he likes it. It could be a fun challenge, and he promises to ask around for me. We part ways and continue with the shopping.

Hilary looks around a wool store while I sit in the corner and eavesdrop on conversations between knitters who are comparing notes about their newest works. We walk over to Terroni and split a pizza and salad because it's late enough in the day to eat again. I am trying to focus on how good the food is and how beautiful Hilary looks in the fall (by all accounts the best season for her colouring), but I can't get Mr. Latinoqueer72 out of my head. How many more minutes will it take to finish our food, to pay the bill, and to walk back home?

. . .

It's night before we get back, but he still hasn't responded.

It's Sunday, and still no response.

Monday morning, nothing. I head back out to Peterborough before dawn. I sleep snug in my two-hour coma before the bus pulls up into the old downtown. I rub my eyes under the bright sun and focus on the lectures I need to deliver today. There is no room to think about anything else.

October 7, 2008

Eight a.m. Tuesday morning. I wake up in my blue bedroom in Peterborough to the sound of my cellphone ringing. Who wants me this early? I fall halfway off my bed and root around for my jeans, for the pocket containing the ringing device. My eyes are still closed, but I feel the smooth silver phone and pull it out.

Hilary's name is printed across the tiny screen. I flip it open before the fifth ring when it will send her off to voicemail land. "Hi, babe."

"He wrote back," she shoots out.

I sit straight up. I push the hair out of my eyes. Adrenaline surges through my veins. This could be it. "What did he say?"

"Well," her voice wavers, "It's not so great." You can always count on Hilary for her direct and immediate take. No cushioning, just the goods. "He says that he's changed his mind, that he doesn't think he's ready to begin an insemination process yet, that he meant to pull the ad from the listserve."

"What the hell?" I shake my head. "Why would he put himself on a listserve to make babies and then not want to make them?" This search has dropped to a whole new pathetic level. I can't even get sperm from a guy who is publicly advertising to give it away.

"Wait," she stops my ranting, "He also says he's still willing to meet with us, if we want." She pauses. "So, do you want to meet with him?"

"Ugh." I cringe at the thought of another pick-up scene. One more act of vulnerability. And the guy has already said he can't do it. Do I have the energy? What clothes should I wear? Will the butch thing turn him off? I don't think most gay men like that stuff. Not the kind of masculinity they had in mind. A few do, but the odds are against it.

I look down at the sheets and find a fresh bloodstain. *Shit.* Day one. Here we go again. I can't stop here. I gotta keep up my

confidence. After all, I have managed to smile and charm my way into a lot of bedrooms in my life, even if most of them have belonged to women.

"Yeah," I sigh, "set it up."

October 7, 2008

Six p.m. I'm on the bus back to Toronto. I'm staring at the rows of tall, broad electricity towers that follow the 401 near Bowmanville. They stand with their arms extended like a parade of dancers. They greet me on every trip, as I move between the two major legs of the commute: the 401 and the 115. My phone suddenly vibrates in my pocket, and I pull it out. I see *Hilary* once more on the screen and ready myself for the news of our meeting with Mr. Latinoqueer72.

"Hi babe, did you set up the meeting?" I whisper between the tall seats, so as not to share my business with the entire bus.

"Yes, coffee, Saturday, at Queen and Bay," she responds, "But that's not why I'm calling." She speaks slowly; her voice is calm, but spacey. Something is wrong. Something out of the ordinary has happened. I panic.

"Is everything okay?" My voice rises and the woman across the row looks back at me, irritated.

"Yeah," she answers in the same vacant tone.

"Are you sure?" I persist because I don't believe her. "Are the kids all right?" Hilary and I joke from time to time that the problem with lesbianism is that women are too in tune with each other. The slightest waver in one of our voices or flicker of an eye and the other one jumps on it. There's no space. I know immediately from one sound out of her mouth that something important has happened.

"The kids are fine," she reassures me. "I have to read you an email I received today."

From: Tammy
To: Hilary
Sent: Tue 07/10/2008 5:31 PM
Subject: Garry

Hi Hilary,

I have an idea for you and Karleen. I asked Garry tonight if he would donate sperm to you, and he said sure. I know he's pretty pasty, which isn't exactly what you want, but at least he's tall and has good genes (the people in his family live a long time). Are you interested?

—Tammy

. . .

"Whoa." I lean my head back against the seat. "I don't believe it."

"Well?" Hilary asks, "How should I respond?"

I'm shaking my head, squeezing my eyes closed. "I don't believe it." Simple and quick. Tammy types a few short lines, presses *Send*, and this huge offer pops up on Hilary's computer screen.

Tammy is a longtime friend of Hilary's. They met in university more than twenty-five years ago. These days, she and Hilary spend time together in two small women's clubs: a book club, and an investment club. Hilary informs me that at their investment club meeting this week, before hashing out the merits of different companies and stocks, they decided to play a game: got 'em, need 'em. Instead of baseball cards, each woman has the chance to say what extra object inhabits her home that she wishes to be relieved of. And, as well, what object she is hoping to come into possession of. When they went around the circle, Hilary mentioned sperm. She needs sperm for her girlfriend. A small object. Vital. Personal. The women laughed a little at the unusual request. They offered her their best wishes in the search.

But Tammy keeps thinking about it through the meeting, the goodbyes, the cleaning up, and still later when she meets up with her boyfriend Garry. She is sitting on his couch, sorting through her emails. Garry's back is turned, as he is perched in front of his computer, typing away. She is trying to think of someone she knows who would be willing to donate sperm. She knows plenty of people, but everyone is either in a relationship, or just wouldn't be willing for some reason or other. And then the thought pops into her mind: *What about Garry?*

She looks up at him. She doesn't hesitate. It's not her style. "Garry, I don't know if you remember meeting my friends Hilary and Karleen, but they're really upset about not being able to have a baby," she announces.

"Uh-huh," Garry mutters from the computer. He vaguely remembers us. He's only met us once as part of a long lineup of friends at Tammy's annual soup party.

"Karleen's been trying for a while, and then last month she had a miscarriage," she explains.

"Oh no." He turns to look at her.

She smiles. "Do you think you'd be willing to donate sperm to them?"

Garry thinks about the miscarriage. He thinks about the opportunity to help friends of Tammy. He thinks that he never wanted kids of his own, but this may be a way to experience having a child, without the day-to-day responsibilities. He doesn't think for very long. He answers, "Sure," and turns back around to work on the computer. Tammy is thrilled that he's said yes without a lot of fuss, and sends her email to Hilary.

Tammy hooked up Hilary with her first husband, and Hilary's ex with his second wife. She is our family matchmaker and, really, it was only a matter of time before she branched off into the baby-making business. Of course. Why didn't I think of it before? We

should have been asking the straight women for sperm all along, not the men. It's the straight women who possess a bit of influence over the sperm. It's the women who might make the friendly suggestion to share it.

I thank Hilary for the news and ask her to wait for me. I'll compose the necessary email when I get home. I stretch out on my seat and rest my face against the cool window. I look out and see dozens of shadows across the way. We're racing in the dark against a Go train beside the highway.

What do I know about Garry? He is a tall, shy, blond-haired, blue-eyed man. A computer expert. A vegan. The boyfriend of Tammy. I know he makes her happy. I like Tammy. She was one of the first people I met when I moved to Toronto. She's a beautiful woman, always ready with a story and a big, easy laugh that is contagious. She is a devout extrovert who will entertain you through an afternoon, and can carry a party. I'm impressed with a guy who can make her happy.

He's not Mexican, not gay (though maybe a bit queer). Does that matter? If I take his offer and it works, it would mean no more bars, no more clinics, no more rejections. But there's still one more coffee to attend to. I've already promised that to Mr. Latinoqueer72, and I feel like I should follow through. My response to Garry is complicated.

. . .

Dear Garry and Tammy,

I can't express how happy I was to get your email. I must admit, I've been hoping for a few years to read something like that.

I wish I had read it a week ago, before I started emailing this man on the queer parenting group. It would make this moment much easier to navigate. I have no idea at this point whether it will work out with him. He sounds somewhat interested, and yet pretty cautious as well. I understand the caution because I know it's a big decision, but I think I'm in a different place. I need to start trying again soon.

The thing is, when I began this process (several years ago now), I gave my friend two years to think about it, at which time he said yes, only to have his boyfriend get very angry and ask him not to. Then I asked a second friend, and gave him another six months—because he could not decide—and in the end he said no. At that point I could not wait any longer and began with the sperm banks. But my first choice has always been to have the donor/father be someone who is known to both me and the child.

To me, your request is ideal. I know I don't know you well, Garry, but what I know, I like. I find you smart, kind, complex. I think you're handsome, and I like how you treat your girlfriend. I adore you, Tammy, and since you have successfully aided in the major family decisions around here, I have every reason to trust and respect your instincts. I like, as well, that you have known a great deal about me for the last decade, and about the rest of the family since before it was even a family. Therefore, your making

this connection, and trusting me in this profound way, means the world to me.

Okay, so how about this? Because I already put the offer on the table, I feel like the only honourable thing to do is to first see whether this man I've been emailing is serious or not. I would hope that I will have this figured out within a week or two—though I can't be 100% sure.

If it does not work out with him, I would like to talk with you right away—maybe the four of us, maybe the two of us, maybe both, and see what you have in mind in terms of what kind of relationship you would want with a child. I am open to a range of possibilities: as a known donor, as an uncle or godfather, or as some level of co-parent. We could talk about this stuff now if you would like, or if you think it would get our hopes up too much, we could wait.

In the meantime, feel free to write or call if you have any questions about my life or my background or anything.

Thank you,

—Karleen

. . .

Hello Karleen,

Garry and I are sitting here together, after having read your email. Garry is going to helpfully add his two cents as I write this.

First, I have to tell you how deeply touched we were by your email. I particularly liked your description of Garry, which I thought was accurate and thoughtful. I think he liked it too. :) He also wants you to know that he is queer, in case that is important to you.

We are completely willing to chat now if you like, knowing that something might not work out if your online person does turn out to be a viable option. And we promise not to be offended or upset in the least if he does work out. Our intent is just to make sure that you guys have a baby, and that's all.

In the long term, we would like to have whatever relationship with the child that works best for you. We were probably thinking something like a known and honoured donor (like we always get invited over for holiday dinners!), but Garry says he's willing to play an uncle-like role if that's what would work best for you. I, of course, will be the somewhat negligent god-auntie who buys birthday presents. And we're also willing to sign anything you want, if that's also important to you.

I didn't even know we were supposed to have questions about your life or background. I've known you a long time, and I think you're the best thing that ever happened to Hilary, and that you're a great mommy to her children, so I don't know what else there

is to know. But perhaps you'd like to know more about Garry's background? He's half Polish, a quarter Norwegian, and a quarter Swedish. He says he takes after the Swedish side.

We just want to be helpful so let us know how best we can do that.

Love,
—Tammy and Garry

. . .

I have a hard time falling asleep on the best of nights. Tonight, with two men in my head, and period cramps tormenting my body, I lie awake for a long time. Hilary breathes deeply in a heavy sleep beside me and I envy her. Garry has changed everything. It is the first sure, solid offer of fresh sperm I've had in so many years of trying. This knowledge calms me. But it feels almost too good to be true. The email communications are not enough for me to wrap my head around the idea. I need to meet with them. I need to hear it from his mouth. I need to see his eyes when he talks about our future baby. I need to know that he cares, that it's important, or even that he likes me well enough. I need to do it now, before he changes his mind. If we can talk this week, we could even potentially do an insemination this month. I don't know if he would want to do it that soon, or whether I'm ready, but it would be nice to have the option.

I turn on the radio. I turn it on so low that I can barely hear the voices. The sound stops the spinning in my head. I need to get some sleep. I need to be clear-headed and alert when I meet these men.

. . .

In the morning I send out panicky emails, and Tammy and Garry agree to meet up with us at their place the next night with no advance warnings or guarantees. It's an awkward endeavour. Neither Hilary nor I know Garry very well. What do you look for when a man stands before you and offers his sperm? When there's no chase. That's a new type of assessment, a new call for criteria. What signs will show that it's okay to enmesh our lives forever? All of my previous desires, indicators, instincts for the father of my baby have not panned out. The sperm didn't work; the relationships didn't work; the dreams didn't work. I haven't been very good at this as of yet, and there's no indication that I'm developing any more insight than when I began the process.

I think I just want to make sure that he's not too weird, or on the other hand not weird enough. Maybe alternative in some way? We should be at least somewhere in line politically. Would he smile if I made a joke? Does he have a sense of humour? Does he really seem okay with having a kid? Does he like kids? Or maybe, simply, can we sit down and have a successful conversation together? Is that enough?

The two couples sit face to face in the lower living room of a split-level condo in the gay village. The room is dimly lit. We sip juices and think of questions to ask each other. Family health is good for both of us.

"There was once a collapsed lung," he explains.

"My grandma had a touch of mental illness," I counter.

Everyone on both sides has lived a long time. (Except for my mom, who died mysteriously of pneumonia at fifty-five, but if the doctors couldn't even figure out what happened, I certainly don't want to bring that up now.) Does he have his own secrets as well? Just how detailed do we need to be?

Ethnicities have been established: if we have a baby, s/he will be 1/8 Mexican, ¼ Polish, 1/8 Swedish, 1/8 Norwegian, 3/8 Britishy stuff, ½ Chicana, full-blooded Canadian.

We were both born on the other side of the continent beside the mountains and ocean. He was born at the northern tip, surrounded by forests, while I, far below, made my way out of an urban desert. But both of us spent our childhoods beside my beloved Pacific Ocean. That's something, I decide, a common body of water. It's comforting.

He is 6'1", tall and slender, and I think those are probably good genes to balance out my short and chubby body. My Aunt Janie will surely approve. All she asked of me those many years ago was to find a tall father, and here Garry is, offering his height to me. It couldn't hurt.

I look at his face, and there is something familiar about it. The glasses, the hair, the fine features. He kind of looks like me. A gentler version of me. If I didn't know for sure that his family came from very different parts of the world than mine, I'd wonder if we were related. I shake my head. It seems funny to look all over the map for the right kind of sperm, only to find someone who looks like me.

Hilary, too honest for her own good, points out, "the kid's not going to have much of a chin." And it's true, neither of us has much in the chin department. *But jeez, Hilary*, I elbow her, *that's not a deal-breaker*. The way I look at it, Garry and I have both managed to procure totally hot and smart girlfriends, and work good jobs— all this with our chins just the way they are. So the chin issue can't be that big of a deal.

"Chins are overrated," Garry shoots back defending us, raising an eyebrow at Hilary.

Tammy keeps us moving forward. "Okay, I've just got to ask it," she blurts out, "What if you and Hilary die? Who takes care of the baby?"

I am stunned for a moment, unsure of the answer. I hadn't thought about that. I don't want to scare them with this

responsibility. I don't want to be a bother. I decide to volunteer my brother in California. He's a good person. He would probably do it. Garry, however, interrupts me offering my brother.

"No, I'd want to do it," he announces, "I'd want to raise our child."

I know we're in the fantasyland of what-ifs, but his quick confidence in this matter endears him to me. Though I hadn't known it before he said it, it's the last piece of him that I need to be certain. I think it's because his answers throughout the evening have been so calm and peaceful. Whatever happens is fine. Whatever I want is fine. Whatever I choose. Whatever I plan. He's cool with it. I start thinking that this has got to be the most easygoing human being on the planet to raise a child with. It's ideal. But then again, I begin wondering what his limits are. At what point does something matter enough for him to stake a claim. And then, here it is, upon our death, he would care for and protect our child.

I promise to contact them with a decision as soon as we have the opportunity to talk with Latinoqueer72.

. . .

Three days later, Hilary and I enter a downtown Starbucks. It is a Starbucks built into the side of a bank, with walls of glass. We can see everyone in every corner of the café, and the crowds of people outside along Queen Street. Hilary and I look around. Which one is he? Nobody looks Latino, and the two other people in their thirties are South Asian. We grab our iced lattes and sit on the bar stools beside a narrow counter. He said to look for a grey sweater and glasses. But everyone in Toronto is wearing either grey or black, so how does this help?

I turn to look to the left, and then to the right, and then to the left once more and find a man approaching me. A good-looking Latino man. Too good-looking to be straight. He must be our Latinoqueer72. He's wearing a grey ribbed sweater and has

a medium build, rounded enough to show his soft chest through his sweater. He's got black slacks. A brown leather book bag over his shoulder. The leather is etched with metalwork from México. His black wavy hair is combed back from his dark brown face. The familiar shape of his face, his gentle manner, his quick, warm gaze—he reminds me of California, of Berkeley, LA, San Diego. He reminds me of home. He's got full, rosy lips that smile as he shakes our hands and gestures for us to come to an outside table with him. It's October but it's still warm, and we three sit together around a tiny metal table.

I try to focus on this new man, but I've still got Garry in the back of my brain. I should've already ruled out Latinoqueer72, or Javier, as he has just introduced himself. The offer from Garry is so generous. Garry is a good man. A known quantity. He seems so cool, laid back, down to earth—the ideal guy if you're looking for a sperm donor. But this Javier, he is the kind of guy I imagined or hoped for when I asked Mateo, and when I bought anonymous sperm online. He's the one. He's the living, breathing man represented by so few words on a listserve. Sitting here before me, I know he is real. His boyfriend may have second thoughts about our plan to make a baby, but I don't. I want him.

"I immigrated here ten years ago," he explains, "All of my family is in Mexico City." He takes a sip of his coffee. "I really want to have children."

"I know what you mean," I say, "I'm far away from home as well. I want to have a kid ASAP." We're both in this new country, hoping to make our roots. "I'm very open to having some degree of co-parenting," I tell him. "We have that set-up with Hilary's ex-husband, and it's worked out really well."

We talk about our lives for the next half hour. He tells of his years struggling to come out while getting his business degree from a university in Monterrey. He talks about his two younger sisters, both of whom have married, and the nieces and nephews

who call him. He sends them a big package of Canadian gifts for Christmas. His dad doesn't like that he's gay, but his mom adores him, and protects him. He's not out to his extended family. He's been with his partner Sean for three years. They live together. They have a dog. He has a photo of the dog on his phone to show us. It's a grey and white curly-haired dog, sitting on someone's lap, panting. Even if Hilary and I are not exactly dog people, we can appreciate the compassion with which he speaks about his dog, and his partner. His partner is twelve years older. He is Canadian, of British roots. He is an accountant. Javier excuses himself to use the bathroom.

Hilary and I look at each other and smile. "You like him too?" I ask.

She nods. "He seems great."

When he comes back, he sits up and looks at me with a serious face. "Sean had kids from an earlier marriage as well, only co-parenting didn't work out for him." He shakes his head and looks out at the pedestrians walking by. "His wife never forgave him for coming out, and she has done everything she can to keep his kids away from him."

"Oh man," I wince, "that must be painful."

"That's why he doesn't want me to have a child, to share parenting with anyone else. He doesn't trust people."

"I can understand that," I pause, "but does he know how much you want this?"

He shakes his head. "I don't know."

"Maybe if he meets us?" I offer, "If we all talk?"

He finishes up his coffee, and looks me straight in the eye, "Look, I know we've just met, but I get a sense of people right away, and I really like you. I'd like to have a baby with you," he sighs, "but my partner and I have already gone through this process with another lesbian couple, right to the end, right to the day I was

supposed to fly to Halifax and give them my sperm. And Sean just freaked out, got jealous, threatened me, and I had to call it off." He closes his eyes and tightens them. "I don't want to put you through that."

"Then why are you here meeting with us," I want to know.

"I think Sean will come around. He just needs a bit more time. We're starting therapy," he stops, takes a breath, and offers, "Could you wait another year?"

I look at this beautiful man, this ideal sperm donor/father, and think about how many men I've tried, and I can't believe I'm doing this, but my head starts to shake and I say, "No, I can't wait." It's not worth it. I can't wait any longer for men who can't make decisions.

He nods, *okay*. "Can you give me a week to ask Sean one more time?"

I think about my ovulation coming up fast, by Friday for sure. I need to give Garry at least two days notice. Don't know where I got that number. I just came up with that. A sperm donor should have at least two days to contemplate becoming a father. So I need to tell him by Wednesday. I turn to Mr. Latinoqueer72 and tell him, "I need to know by Tuesday."

. . .

I'm speeding down the 115, the rolling fields darkening in the dusk. The pink sky beyond is breathtaking, but it's quickly disappearing into night. I talk to Hilary on my cellphone.

"Why don't you just take another month to think about it?" she asks reasonably.

We won't have the final word on whether Latinoqueer72 will give us his sperm until Tuesday. He was so soft, and pretty, with big, dark eyes, his silver bracelet on his brown wrist, his Mexico City accent lingering in my ears. Won't he do it? If only his boyfriend wasn't so insecure. What's with these gay guys anyway? Why are

they so worried about giving some of their sperm? Why are they afraid to make babies with lesbians? Why do they need so much control? I can share. Sharing is easier. Who wants a kid 24-7? Do they know anything about kids? Maybe he'll smooth things out with his boyfriend. Maybe he'll call and tell me yes.

But if it doesn't seem like it will work out, then I want to confirm with Garry. The problem is that it would only give Garry two days to think about it. Maybe that's not fair. Maybe he'll think I'm a jerk for putting such a short timeline on it. How can I switch from one guy on Tuesday to him on Friday (day eleven)? Well, they say my mom was dating another man only a month before she married my father.

The only thing I know for sure is that I want to try this month. And it's not rational. It's hunger. Pure aching from the gut. Sometimes at dusk I get this desperate feeling. I worry that the darkness will not only take over the land, but take over my little body as well and I will disappear. At once the sky seems enormous and crushing, and I have to stop myself.

I need to try this month.

. . .

I check my email just before bed to see once again if Javier has written, but another note catches my eye.

From: Tim
To: Karleen Pendleton Jimenez
Sent: Tue 14/10/2008 6:07 PM
Subject: Daddy

Hi Karleen,

I found a guy for you. He's Ecuadorian, gay, very cute, a grad student at OISE. He cannot support a child financially, but he

loves kids, and really wants to be a father. Do you want his email?

—Tim

. . .

Oh, for fuck's sake. This is ridiculous. No offers for years, and now two offers in a week. I wait and wait for Mr. Latinoqueer72, and nothing, no email, no phone call, nothing. And here's Tim on my laptop, after a chance meeting on the street, with the subject heading: *Daddy.* Why hadn't I asked Tim years ago? He could have saved me from the bars and the clinics. He's one of the few white guys around town who knows Spanish. The skill has always given him a special connection to the Latino community. I should have known. I should have made a list of every man and woman I knew and all the potential men they might know. I should have contacted each one, and specified my interest and the scope of possible parenting roles we could each have played. But my drive toward making this baby, however intense and committed, has also been hindered by insecurities. I'd like to call it a desire for privacy. That sounds more conscious, more active, as if I am purposely only telling certain people in my life about this hope to have a baby. As if I have clear delineations between who is in the know and why.

But it hasn't been like that. It's haphazard. It's how I feel on a given day, how confident I am, or how desperate. It depends on whether or not I can bear another person's gaze once I confess that I have this womanly desire, an animal urgency, to make a baby. Would they see me as less of a butch? Would they see me as less of a scholar? Or as less of an activist? Would I be too selfish in putting my own want in front of the needs of the community, or the struggle for social change? Can I accept that if I do not get pregnant they will know this vulnerability in me?

It's time to let go of all of this shit and get on with making a baby. I don't know the Ecuadorian, however lovely he sounds on paper—the Latino of my baby daydreams. But I'm tired of

meeting up, eyeing each other, and feeling the sperm slip through my fingers. I've no need to subject myself to any further rejection, even if the adventures have been worthwhile. I'm done.

I barely know Garry. He doesn't look like the man I envisioned when I started this process, but maybe that was the wrong approach. The universe has been known to knock you on your ass when you try to control it, but it can also offer you gifts if you're willing to pay attention. Garry is a gift. He has looked me in the eye and promised me his sperm and promised the child his protection.

Friday, October 17, 2008

Hilary doesn't like plastic. She doesn't trust drinking from plastic cups or serving food in plastic bowls. She's not about to start a baby's life in a potentially toxic container. She rummages through the cabinets for one of our little glasses (a former mole sauce jar). She eyes its size and shape (approximately two inches in diameter, and six inches long) and nods. She's ready to go.

We grab our coats and scurry out the door. On the drive across town, I fret. I feel like I'm heading to a party empty handed. They're offering me the world, and I've got no idea how to return the favour: no flowers (it's 7:30 a.m. and no flower store is open), no booze (they're not really drinkers), no croissants (he's vegan). I don't know how or if they like coffee, and a card seems a bit cheesy. *Shit.* Shouldn't I bring them something? What exactly is the etiquette for a social event of this nature?

I confess my inadequacy to Tammy at the door, who quickly brushes it aside and infects us with her giddiness. "Follow me," she announces, "we've decided to give you two the bedroom."

· · ·

Four people. Two rooms. Two couples in love. Four lovers making a baby.

. . .

Hilary and I lie in the bedroom. I bend over her, caressing her face, kissing her neck. I feel her body beneath me, her breasts pushed up against mine. I slip my hand under her ass and squeeze. I close my eyes and fantasize about getting her pregnant. In my butch mind, it's the closest fantasy to the real thing that will turn me on. When I open them again, Hilary is smiling.

"What?" I ask.

She whispers, "What do you think they're doing over there?"

The house is silent.

Our baby begins on the other side of the wall. Tammy is the muse. Garry produces the precious drops of life.

There's a knock on the door. Hilary leaps up and Tammy quickly hands over the small glass. The two friends of twenty-five years lay the path between sperm and egg.

Hilary loads the syringe, sets it beside us, and pushes me down. She is stronger than me and wrestles, like we're playing a game. I laugh, but she only tightens her grip. She is serious about this. She is focused. She kisses me as she begins working at my jeans, unbuttoning, unzipping, holding me firmly between my legs. I breathe out, abrupt, heavy, letting go of the weight of my body, the weight of nearly two years of doctors, five years of men, fifteen years of planning. I let go and give myself over to Hilary's expert hands.

Statement of Live Birth
Sex of Child: Female
Birth Date: July 29, 2009
Weight of Child at Birth: 9 pounds, 7 ounces
Place of Birth: Toronto
Exact Location Where Birth Occurred: Mount Sinai Hospital

how to get a girl pregnant

Acknowledgements

♦

Thank you for all the support in the process: Elaine Jiménez McCann, Julia Curry-Rodriguez, Celia Haig-Brown, Heather Cook, Garry Pejski, Tammy Sturge, Lisa Walter, Judith Perry, Rachel Epstein, Yvanka, Miriam Davidson, Karen Shenfeld, Susan Dion, Christine Cho, Barb Taylor, Eden Torres, Jacqueline Muldoon, Marusya Bociurkiw, Janet Romero, Valeska Gomez-Castillo, Cara Ellingson, Pariss Garramone, Christine McKenzie, Elizabeth Vlietstra, Farzana Doctor, Heather Algie, Daniel Sos, Brenda Zavala-Antunez, Katerina Cook, Carter Cook, Brian Pendleton, Arlene Pendleton, Elena Pendleton, and Nancy Cardwell.

And thanks to the potential sperm donors/fathers along the way.

About the Author

Karleen Pendleton Jiménez is the screenwriter of the award-winning film Tomboy, and author of the children's book Are You a Boy or a Girl?, a finalist for the Lambda Literary Award. She teaches in the School of Education at Trent University. Raised in LA, having lived in Berkeley and San Diego, she now makes her home in Toronto.